BRIDGET RILEY
PAINTINGS FROM THE 1960s AND 70s

With texts by

Lisa G. Corrin
Robert Kudielka
Frances Spalding

Serpentine Gallery

18 June – 30 August 1999

Front cover:
Movement in Squares
1961
Arts Council
Collection,
Hayward Gallery,
London

This catalogue is published to accompany
the exhibition
Bridget Riley : Paintings from the 1960s and 70s
Curated by : Lisa G. Corrin and Julia Peyton-Jones
in collaboration with the artist
Exhibition Organiser : Emmanuelle Lepic

Sponsored by
Bloomberg News

In association with

THE TIMES

Catalogue made possible by The Paul Mellon Centre
for Studies in British Art

The Serpentine Gallery is supported by the Arts Council
of England and the Westminster City Council

Prepared and published by the Serpentine Gallery,
London

Edited by Lisa G. Corrin
Production by Leigh Markopoulos

Designed by Richard Hollis
with Maya Stocks

Printed in Great Britain by Balding + Mansell, Norwich

Serpentine Gallery
Kensington Gardens, London W2 3XA
Telephone : +44 (0) 171 402 6075
Fax : +44 (0) 171 402 4103

ISBN 1 870814 17 7

Published by order of the Serpentine Gallery,
London, 1999

SPONSOR'S FOREWORD

Bloomberg News is very pleased that the second exhibition we are sponsoring at the Serpentine Gallery should be a major survey of Bridget Riley's works from the 1960s and 70s.

Bloomberg is a global multimedia news and information company that continually seeks to bring news to an ever-widening audience. We have formed a working relationship with the Serpentine that reflects Bloomberg's philosophy of innovation and quality. Since the initial involvement with the Gallery's reopening celebrations in February 1998, we have formed a creative partnership with the Serpentine that we have found stimulating, satisfying and extremely rewarding. Michael Bloomberg, our founder, has subsequently joined the board of Trustees of the Gallery, and in the summer of last year we sponsored the *Mariko Mori* exhibition. We are very proud that the latest development should be the opportunity to support the work of a British artist of such eminence and influence as Bridget Riley.

An essential part of our corporate philanthropy, reflecting the personal philosophy of Michael Bloomberg, is to give something back both to the community we work in, and to our employees, who now number 1,000 in London. The Serpentine's enlightened exhibition and education programmes and great accessibility are important to Bloomberg News as we are committed to increasing access to the arts and helping to widen cultural interest. It is with great pleasure that we take a further opportunity to show our commitment to the Serpentine Gallery's work with the sponsorship of this *Bridget Riley* exhibition.

Bloomberg News

DIRECTOR'S FOREWORD

A Bridget Riley exhibition has been a gleam in the Serpentine Gallery's eye since 1994 when we first approached the artist regarding an exhibition encompassing her paintings of the 1960s and 70s. It was the Serpentine's dearest wish to persuade Bridget Riley that our rooms would offer the perfect setting for a survey of this extraordinary aspect of her career. We spoke at length about the characteristics of the Gallery – the light and the proximity to nature – that distinguish the Serpentine and make it particularly sympathetic to the showing of paintings. At the time the artist was approached, the exhibition *Bridget Riley : Paintings 1982-1992* had recently taken place at the Hayward Gallery. The Serpentine, however, felt it was important that the public see again classic works from the decades preceding this exhibition. These works, for a new generation particularly, were known mostly through reproduction, not having been shown as a group in this country for almost thirty years. We were, therefore, elated when our proposal was accepted by the artist last year. The enthusiasm with which the Serpentine Gallery team took the project forward was matched by the overwhelmingly positive response of the public when we announced our intentions.

The scale of the Serpentine often dictates that an exhibition be sharply focused on one aspect of an artist's oeuvre. This focus enables the visitors to the Gallery to gain an in-depth understanding of a unique body of work or a revised interpretation of an artist's achievement. This perspective shaped, for example, exhibitions of the work of Andreas Gursky and Louise Bourgeois which have taken place here over the last six months. For Bridget Riley's exhibition, we wished to present a coherent body of work that, nonetheless, would also allow for a future retrospective exhibition elsewhere, surveying in its entirety the achievement of one of Britain's most important artists.

Accordingly, the exhibition at the Serpentine charts the evolution of Riley's practice from the first black and white painting of 1961, to the introduction of grey and, finally, the move into colour. *Andante* (1980-81), the last work in the exhibition, marks the completion of her remarkable curve paintings. Thirty-three works follow the progress of a young artist who quickly hit her stride to produce one of the most distinguished bodies of work of her generation.

This exhibition has been selected by Bridget Riley together with Lisa Corrin, the Serpentine Gallery Curator, and myself. Our collaboration has been immensely rewarding and has resulted in an exhibition of which we are very proud. Our appreciation of Bridget Riley's thoughtfulness about every aspect of the exhibition, from its content to its presentation, is enormous. We also wish to acknowledge the invaluable support that her London dealer, Karsten Schubert, has given to our exhibition from the moment of its inception, as well as throughout the project.

We are delighted that the lenders to this exhibition have so generously agreed to entrust their paintings to our care. These important works will be a revelation not only to those less familiar with them, but also to those who have followed Bridget Riley's career from its early days. The assistance of Thomas Dane and Susanne Kudielka has been particularly helpful in our discussions with collectors.

The objective of this catalogue has been to lay the foundations for a new generation of scholars and artists. Frances Spalding, an eminent art historian of twentieth-century British art, surveys the formation of Riley's thinking by observing her artistic development and reviewing the contributory influence of teachers and mentors. Robert Kudielka, Professor of Aesthetics and Philosophy of Art at the Hochschule der Künste, Berlin, has generously made part of his forthcoming monograph on the artist available and has

contributed a detailed analysis of the development of Riley's work in the sixties and seventies. Lisa Corrin's essay reviews the period covered by the exhibition from the vantage point of the nineties and considers critically the reception of Riley's work both in its time and by contemporary artists. I am grateful to all three contributors for the insights garnered through careful study of the artist's work.

The Paul Mellon Centre for Studies in British Art made a very generous contribution in support of this catalogue and we are indebted to them for assisting us in making this material available to the public. We thank Richard Hollis for designing this catalogue and we wish also to express our gratitude to the following who have helped in the preparation of the catalogue: Brian Butler, Marta Braun, Peter Davies, Mark Haworth-Booth, Philip Taaffe and Diana Thater. Special mention is due to Lord Snowdon and Roger Eldridge, of Camera Press, for their kindness in allowing us to reproduce one of the most handsome photographs of the artist in this catalogue.

We are delighted to be collaborating with Bloomberg News who are the sponsors of this exhibition. Through their generosity they have enabled the Serpentine Gallery to realise this project to the highest standard. In addition, the media sponsorship of *The Times* has ensured that news of the exhibition reaches the widest possible public and we are most appreciative of this benefit to the artist and to ourselves.

The Serpentine Gallery is grateful to Her Majesty's Government for its help in agreeing to indemnify the *Bridget Riley: Paintings from the 1960s and 70s* exhibition under the National Heritage Act 1980 and to the Museums and Galleries Commission for its help in arranging this indemnity.

Our heartfelt thanks are due to the many people who have contributed to the successful organisation of this exhibition. Lisa Corrin's dedication and experience have been pivotal in the realisation of this exhibition and publication. In addition I would especially like to mention Bridget Riley's personal assistant, Camilla Wallrock, who has worked closely with the Serpentine Gallery; Mike Gaughan, Gallery Manager, who has led the installation team; John Johnson, who supervised the lighting design, and the exhibition organisers Emmanuelle Lepic and Leigh Markopoulos who worked together on the exhibition loans and the production of this publication respectively.

Bridget Riley particularly would like to thank the studio assistants who have worked with her during the period covered by the exhibition: Bob Earl, Rita Marshall, Peter Hananer, Derek Bence, Bob Quick, Steven Selwyn, Vicky Hawkins, Andrew Smith and Philip Ward.

We would have been unable to realise this exhibition without all those at the Serpentine and outside the Gallery who have been so generous with their time and assistance. It is a tribute to the artist that the great affection and esteem in which she is held has galvanised such commitment.

The most important thanks of all, of course, goes to Bridget Riley herself. Throughout the organisation of this exhibition she has taught us to see not only painting, but the world around us, in unexpected ways. She has been gracious and open to dialogue and new perspectives on her work. We are deeply grateful to her for her generous participation in every aspect of this project.

Julia Peyton-Jones
Director
Serpentine Gallery

Arts Council Collection, Hayward Gallery, London
Museum Boijmans Van Beuningen, Rotterdam
The British Council
The Family of Paul M. Hirschland
Camille Oliver Hoffmann
m Bochum Kunstvermittlung, Bochum, Germany
The Museum of Modern Art, New York
Neues Museum. Staatliches Museum für Kunst und Design
in Nürnberg
Collection Helga and Edzard Reuter, Stuttgart
Sheffield Galleries and Museums Trust
Tate Gallery
Heinz Teufel and Anette Teufel-Habbel, Berlin
Collection Manfred Wandel, Reutlingen
Westfalenbank AG, Bochum

and all those collectors who wish to
remain anonymous

Bridget Riley
Tremor 1962
Emulsion on hardboard
Private collection

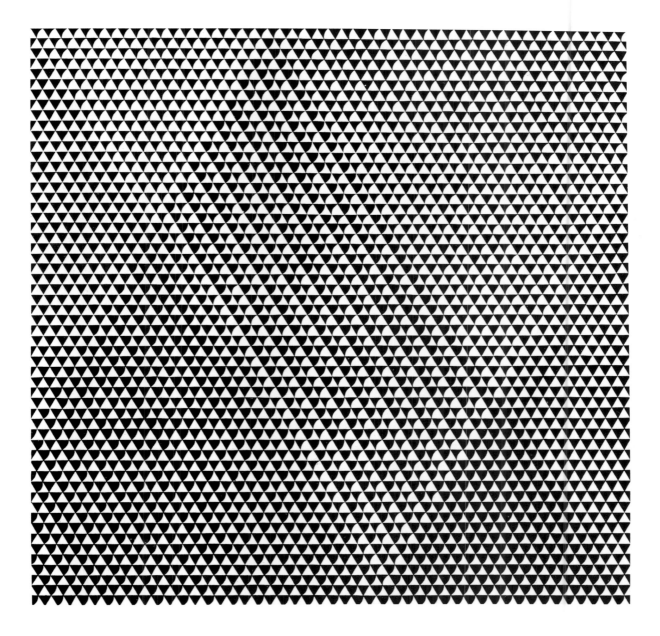

10

BRIDGET RILEY
AND THE POETICS OF INSTABILITY

Frances Spalding

'Nature is on the inside,' says Cézanne. Quality, light, colour, depth,
which are there before us, are there only because they awaken an echo in our body
and because the body welcomes them.[1] — MAURICE MERLEAU-PONTY

One of the most radical moves in the history of post-1945 British art was Bridget Riley's decision to destabilise the image. When she first began working with the energies inherent in purely pictorial relations in her black and white paintings of the 1960s, she shifted the arena for dramatic confrontation from the surface of the canvas into the space between the spectator and the work of art, as Bryan Robertson has observed.[2] Brought into dialectical process with the eye, the surfaces of her canvases appeared to shimmer, buckle, jitter, heave and twist. Later, as she moved through coloured greys into colour, making her chosen unit the stripe, she saw that 'the basis of colour is its instability'.[3] The realisation that she could exploit the way in which colours resonate, interact and spread, each stripe affecting and modifying its neighbour, again reaffirmed the necessary dialogue between eye and image, the content of the work only fully existing when activated by the dynamics of looking.

This new exhibition invites reassessment of Bridget Riley's work of the 1960s and 70s. It is, therefore, an apt moment to explore some of the intellectual roots that fed into her creative process; to investigate those tracings and promptings that spurred her imagination and which led, directly or indirectly, to the manifestation of movement in her art, fleeting presence and the visual dialectic of action and counteraction, all of which contribute to an unsettling discrepancy between pictorial fact and aesthetic effect.

The denial of fixity in her art has proved richly rewarding. As the artist herself has observed, a loss of certainty or focus can open up a new range of experience, so that we become 'open to things that were previously less accessible'.[4] In the course of this century advances in science, such as quantum mechanics and Heisenberg's uncertainty principle, have exposed the unpredictability within nature and have dissolved the separation between a deterministic world and the impartial human observer. This classic dichotomy became no longer tenable once the act of observation was seen to affect the thing observed. And although there is an enormous distance between particle physics and the world of art, the repercussions have been undeniable, Cubism, for instance, playing in part on the recognition that the perceiver's situation had to be taken into account. This acknowledgement of an inherent uncertainty may be one reason why Bridget Riley's work, far from receding into history as a period style, continues to zing with challenging authority. Its relevance to a younger generation of artists has been actively demonstrated in a variety of ways. In the mid-1980s Philip Taaffe appropriated 'Op art' images by Riley, which he found 'emotionally and psychologically compelling', in the course of his postmodernist investigation into the achievements of late Modernism.[5] More recently, Damien Hirst has acknowledged Riley as the starting point for his 'spot' paintings; and Peter Davies, listing idols and mentors in one of his text paintings, included the accolade, 'Bridget Riley so complicated but such eloquent funky results'. More generally, Riley's committed stance has helped sustain and renew an interest in abstract painting. Her work also has relevance in the pres-

1. Maurice Merleau-Ponty, 'Eye and Mind', *The Primacy of Perception and Other Essays*, Evanston, Ill: Northwestern University Press, 1964, p. 164.

2. *Bridget Riley: Paintings and Drawings 1951-1971*, introduction by Bryan Robertson, London: Hayward Gallery, 1971.

3. *Bridget Riley: Dialogues on Art*, ed. R. Kudielka, London: Zwemmer, 1995, p. 56.

4. *The Eye's Mind: Bridget Riley: Collected Writings 1965-1999*, ed. R. Kudielka, London: Thames & Hudson, 1999, p. 91.

5. For Taaffe's discussion of his use of Riley's work, see 'Philip Taaffe', in *Flash Art*, no. 124, October/November 1985, pp. 72-73.

Peter Davies
Text Painting (detail)
1996
Acrylic on canvas
The Saatchi Gallery,
London

ent climate in which, chiefly owing to critical theories which have followed a similar path to scientific thinking, categories have become unfixed and meaning is often seen to be ambiguous, elusive and unstable. The opposition posited by the 1960s imperative – 'Make Love Not War' – rings hollow today, not least because such violent hierarchies can be undone, reversed, as Derrida has shown. Likewise, the abstract/figurative debate, which was so vital at the time when Riley began her career, still identifies two diametrically opposed ways of making art but has altered its tenor with the growing recognition that abstract art can be rooted in bodily sensations and can act as a compelling vehicle for human experience.

Intense looking is a condition of Bridget Riley's art. Her career began in traditional fashion with an interrogation of appearances. John Rothenstein claimed that she gained admission to Goldsmiths College in 1949 on the strength of her copy of Van Eyck's *Man in a Red Turban*, whose sharp, astute gaze has encouraged the theory that the painting may be a self-portrait.[6] At Goldsmiths she worked compulsively at life drawing, under the tutelage of Sam Rabin, and developed an interest in the drawings of Ingres which, with their incisive accuracy, uniquely blend the particular with the universal. Riley has acknowledged her debt to Rabin, who not only took her to the British Museum print room to study drawings by Ingres, Rembrandt and Raphael, but also taught her to work methodically, to strip down visual imagery in order to uncover its structure and to develop a sense of pictorial organisation.[7] 'He stressed the importance of the relationship between things,' she recollects; 'how everything matters . . . how to make an advance and consolidate . . . how to raise the level of work slowly. That was gold – and something I have kept with me.'[8]

Rabin's contribution to Riley's career has often been acknowledged. Much less attention has been given to the fact that another key figure at Goldsmiths at that time was Kenneth Martin. He was then moving away from the Camden-Town and Euston-Road-School method, so prevalent at English art schools during this period, into an abstract language, in which field he was to be closely allied with Victor Pasmore and the 'constructionists'. Following Pasmore's example, Martin made his first non-figurative painting in 1948 and his first abstract mobile in 1951. Though Riley at this time did not conceive of herself as anything other than a figurative artist, and was aware that Kenneth Martin despised

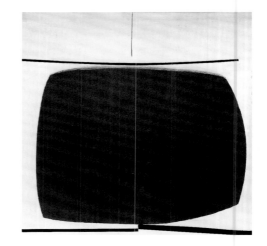

Victor Pasmore
Yellow Abstract 1960-61
Oil on board
Tate Gallery

life drawing, she noted his presence and was familiar with his work.* This knowledge she added to what she already knew about abstract art, for, having spent the war years in Cornwall, she had heard of Ben Nicholson's and Barbara Hepworth's association with St. Ives and had gained some understanding of their work. Nicholson had featured in one of the Penguin Modern Art series and this small but influential book had been brought to her attention by her mother. But if she was already intrigued by what lay beneath when subject matter in art is stripped away, she found no clear directional signposts at the Royal College of Art to which she transferred in 1952. Her three years there were followed by an unhappy period in which she nursed her father, following a serious car accident, and was herself hospitalised owing to a nervous breakdown. She worked as a shop assistant while regaining health, then taught art for a period in a convent

Kenneth Martin
Abstract Green and Brown (3)
c.1948
Oil on canvas
Courtesy Annely Juda Fine Art

6. See John Rothenstein, *Modern English Painters : Wood to Hockney*, London : Macdonald and Jane's, 1974, p. 213.

7. *The Eye's Mind*, op. cit., p. 24.

8. Ibid., p. 15.

* Riley remembers him as a 'Corridor Meister'.

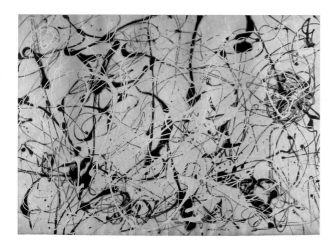

Jackson Pollock
Number 23 (1948)
1948
Enamel on gesso on paper
Tate Gallery

9. Quoted in John Gruen, *The Artist Observed : 28 Interviews with Contemporary Artists*, Chicago Review Press, 1991, p. 155. See also her comments quoted in Jeremy Lewison, *Interpreting Pollock*, London : Tate Gallery Publishing, 1999, p. 9.

10. See her comment in *The Artist Observed*, loc. cit., 'I remember looking at my first Jackson Pollock, I know it seems ridiculous, but I wept all night over the colossal [emotional] price involved . . . Pollock and also Mark Rothko were enormous revelations to me.'

school in Harrow. Following this she did the first of two stints in the offices of the advertising agency, J. Walter Thompson, where she was assigned to the making of preparatory drawings as the basis for subsequent work by photographers.

During this ragged period of intense artistic and personal crisis, she encountered Abstract Expressionism. Like many other artists of her generation, she first experienced its impact at the 1956 Tate Gallery exhibition *Modern Art in the United States*, which contained in its final room work by Gorky, Kline, de Kooning, Motherwell, Pollock and Rothko. Riley has put on record her response to this show as bearing witness to modern art as 'a living, ongoing reality *now*'.[9] Pollock especially impressed her, and she felt 'inordinately moved by the extreme measures' that he had adopted in his art.[10] Two years later a major Pollock exhibition at the Whitechapel Art Gallery reinforced the impression she had gained of his enormous vitality and artistic courage. At first glance it is hard to see what relevance his freely rhythmic, open linear compositions had to her later development of a precise and measured visual language. But in the work of both artists can be found a desire to explore the architectonic potential of the picture plane, also a stress on an evenness of expressive emphasis to give the work plastic coherence. Pollock's work also showed the use of an open, shallow, multi-focal space, with which Riley feels more sympathy than 'the focally centred situation of the European tradition'.[11] And it is possible that at some level the vibrant energy of Pollock's drip paintings, and the absolute stillness that sometimes emerges from within their surging network of lines, encouraged Riley's own search for a dynamic equilibrium in which painting, no longer a self-contained activity,

is always in a state of becoming, and all emotion, no matter how fleeting or extravagant, is translated into pictorial sensation, to be caught on the wing by the creative attention of the spectator.

Even in the late 1950s, Riley recognized the tragedy in Pollock's art – that the tremendous liberation he had achieved, through his reliance on instinct, led to a cul-de-sac, the conditions of its success being also those of its failure.[12] In 1959, the year after the showing of his art at the Whitechapel, she not only saw at the Tate Gallery the *New American Painting* exhibition, devoted entirely to Abstract Expressionism, which made an indelible mark on her, but she also visited *The Developing Process* exhibition at the ICA. The show consisted of work produced in the Fine Art Departments of Leeds College of Art and King's College, Newcastle, around the 'Basic Design' principles promoted by Harry Thubron, Maurice de Sausmarez, Pasmore and Richard Hamilton. This method of art education had its origins in the Bauhaus, and in particular the pedagogic work of Paul Klee, and it endeavoured to give the student information on the nature of materials, colours and the operation of formal and spatial relationships. Thubron worked, for instance, with families of form, showing how shapes could evolve and change in character. By making reference not only to the study of nature but also to mathematical, geometrical and scientific forms, he hoped to widen the field of comparative study. Riley was extremely interested and took part later that year in a summer school in Suffolk, led by Thubron, with assistance from, among others, de Sausmarez, the art historian Norbert Lynton and Anton Ehrenzweig. Ehrenzweig was to write a major essay on Riley's art [13] and analysed 'art's deep substructure' in his book, *The Hidden Order of Art* (1967), which drew, in part, on his conversations with Riley and knowledge of her art.

Thubron's summer school proved the turning point, an important aspect of the course being a survey, part practice, part theory, of the major art movements of the twentieth century. Although Riley had read fairly widely as a child, she now developed a more specialist appetite for books that had direct relevance to her painting.[14] She was partly helped to do so by her association with Maurice de Sausmarez, painter, writer, lecturer and broadcaster whose book on Basic Design had a wide-reaching influence on art education. He became an intimate friend, the two travelling in Spain and Portugal in the summer of 1959 and touring Italy in the summer of 1960. At that time little had been published in English on Italian

11. 'In conversation with Bridget Riley', in Maurice de Sausmarez, *Bridget Riley*, London : Studio Vista, 1970, p. 62. In the same passage Riley also acknowledges a debt to Mondrian, '. . . I tend to work with open area space – and when I refer to this as American space we must not forget that it had its origins in Mondrian. It demands a shallow push-pull situation and a fluctuating surface.' Reprinted in *The Eye's Mind*, op. cit., p. 62.

12. Conversation with the author, 3 March 1999. See also *Interpreting Pollock*, op. cit., p. 9.

13. Anton Ehrenzweig, 'The Pictorial Space of Bridget Riley', *Art International*, vol. IX, no. 1, February 1965.

14. Riley has listed those books which had especial importance to her, in the order in which she encountered them, in conversation with Isabel Carlisle. See *Bridget Riley; Works 1961-1998*, Kendal : Abbot Hall Art Gallery, 1998, p. 10.

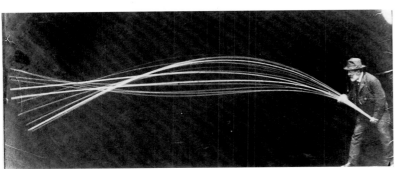

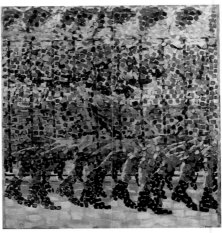

Futurism, which, like Dada, had become a largely forgotten aspect of modernist art history. De Sausmarez was the first person to lecture on this subject in London, giving three talks at the Royal College of Art on the occasion of the fiftieth anniversary of the Futurist Manifesto. He not only developed his ideas for these lectures in conversation with Riley but with her made an abortive attempt in the summer of 1960 to visit one of the original founders of the Futurist movement, Gino Severini, who was too ill to see them. But one of the memorable aspects of this trip for Riley was the exhibition of Futurist art which formed a part of *Venezia XXX Biennale Internazionale d'Arte*.

If Futurism, both formally and conceptually, is overshadowed by Cubism, it has nevertheless come to be recognised as one of the most important progressive movements in twentieth-century art. Though initially concerned with literary reform, it quickly expanded to embrace painting and sculpture, architecture, music, theatre and film. A series of provocative, anarchical manifestos, full of rhetorical flourish and nationalistic sentiment, urged readers to immerse themselves in the dynamism of modern life. In Severini's view, the modern sensibility was particularly adept at grasping the idea of speed. When confronting the paradox of how to represent movement within the static confines of a two-dimensional canvas, the Futurist painters drew on their awareness of the chronophotography which the pioneer in time-motion studies, Etienne-Jules Marey, had developed in the 1880s. He had succeeded in making visible the invisible, through photographic inventions which enabled him to capture successive spatial movements, both the figure or animal and its trace, by means of a single camera. Fascinated also with the

greater pace of life made possible by technological advances, the Futurist painters promoted in their manifestos the idea of 'universal dynamism' and 'dynamic sensation' and, generally, an overriding desire to register, and thereby render eternal, both the sensation of speed and its emotional character.

In Venice Riley had an opportunity to study at first hand the pictorial solutions arrived at by the Futurists. These became noticeably more complex after they assimilated aspects of Cubism in 1911. As the moving figure or object, multiplied or fragmented, passes through, and interpenetrates, space, the material consistency of the perceived world is destroyed. What instead becomes pronounced is a fresh sense of sequence and rhythm, a visual pulse working often across the entire field. This search for a pictorial equivalent to the dynamism of modern life led the Futurists to talk of 'lines of force' which, they argued, not only conveyed the character of an object but also how it might unfold and develop in space as it tended towards infinity. Giacomo Balla's attempt to uncover the inner life, energy or 'emotion' of lines and colours led him into the field of non-figurative art.[15] For Riley, this search for equivalence was more important than the concern with movement, which she was to discover in her own way when she began subjecting forms to a method which she had yet to evolve. But the Futurist desire to draw the spectator into the work of art set a useful precedent for Riley's work. As the Futurists wrote: 'He [the spectator] will no longer simply observe but will participate in the action The lines of force must envelope the spectator and draw him on so that in a way he is compelled to fight along with the figures in the picture'.[16]

15. An achievement that has led to him being recognised as an important precursor for Italian Minimalism. See *Minimalia : Da Giacomo Balla a . . .* , catalogue to an exhibition held at the Palazzo Querini Dubois, Venice, in 1997.

16. Catalogue introduction to the 1912 Futurist Exhibition, shown in Paris, London, Berlin and ten other European cities.

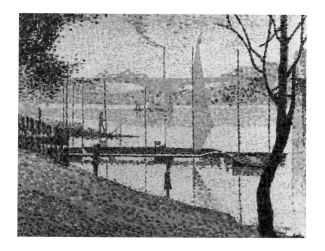

Bridget Riley
Copy after *Le Pont
de Courbevoie* by
Georges Seurat
1959
Oil on canvas
Private collection

One painting which particularly impressed Riley in the Venice exhibition was Balla's *Girl Running on a Balcony*, which, employing a divisionist approach, renders movement through a mosaic of colour. This method of dividing up compound colour in nature into separate touches in order to register light, shadow, local colour, reflected colour and the overall ambience, was already familiar to Riley through her study of Impressionism and Neo-Impressionism. The previous year, 1959, she had copied Seurat's *Le Pont de Courbevoie*, working not from the original in the Courtauld Institute Galleries (now the Courtauld Gallery) but from a reproduction. As this suggests, there was no attempt to imitate Seurat's pointillist touch or the beautiful surface texture created by his tiny dots of colour. Riley's decision to copy Seurat was fired by her desire to know what colours he had used and to find out what he had put where and why. And as the painting proceeded, she discovered that the blues and yellows, in their alteration of pitch, kept pace with each other, working together through a network of balanced contrasts.

Riley's appreciation of the divisionist method was heightened by her awareness that it had formed the basis of many artists' colourism and structural thinking. Important to Gauguin, Van Gogh and Matisse, as well as the Futurists, it therefore had a validity not confined to any one period or style. She connected this realisation with the possibility of an abstract art that was universal and could transcend cultural barriers. Debates on the universality of art were current at that time, as she was aware through her reading of art magazines and growing familiarity with the contemporary art scene at home and abroad. At the same time Clement Greenberg was promoting a greater degree of 'singleness and clarity' in abstract art, encouraging a development away from the subjective excesses of Abstract Expressionism towards a cooler 'post-painterly' or 'hard edge' abstraction. In Greenberg's view, an abstract painting should insist on its own material attributes, on paint, the shape of the canvas and its own ineluctable flatness; the whole of the picture should be taken in at a glance and its unity should be immediately evident, its 'at-onceness' affecting the viewer like a sudden revelation.[17]

Riley had met Greenberg in New York and saw him a couple of times in London at Anthony Caro's house. However, although attracted to a cooler, more objective approach, she was less in tune with New York formalism, feeling more at ease with the openness of European attitudes to abstract art which were rooted in Cubism and aimed at transcending the personal approach. Riley, herself, removed her own hands from the process of making around 1961, handing over the fabrication of her work to studio assistants, thereby marking out a clear distinction between creative work and the craft necessary for its execution. But she did not, as certain geometrical abstractionists and constructivists did, turn to industrial methods and materials, nor did she patronize the notion of group work, anonymous authorship and the making of 'multiples'. These and other notions were fostered by certain European collectives, such as Gruppo N, an association of artists founded in Padua in 1959, and Equipo 57, formed by five Cordoban artists in 1957, the latter exhibiting at Denise René's gallery in Paris which became a focus point for geometrical abstraction and for 'multiple' art. As Riley did not agree with the latter, she kept away from this gallery, a decision that reflects on her need to stand apart from prevailing ideologies and styles in order to establish her own line of enquiry.

Although much geometrical abstraction at this time was directed towards a socialist society, it had no overt political content. The situation was very unlike that which had prevailed in revolutionary Russia where non-figurative art was employed as propaganda, and also in the 1930s when abstract art had again been aligned with political idealism and associated with a 'free' international style. By the 1960s abstract forms were no longer burdened with iconic and symbolic associations or political overtones. 'They were simply forms without pretensions,' Riley recollects, 'in a condition for working with. Just "to hand".'[18]

Riley was certainly not alone in her gradual move towards an abstract language based on optical effects. An

17. Clement Greenberg, 'The Case for Abstract Art', *Clement Greenberg: The Collected Essays and Criticism: Volume 4: Modernism with a Vengeance 1957-1969*, University of Chicago Press, 1993, p. 81.

18. 'Bridget Riley in conversation with Robert Kudielka', *Bridget Riley: Paintings and Drawings 1961-1973*, London: Arts Council of Great Britain, 1973. Reprinted in *The Eye's Mind*, op. cit., p. 82.

interest in the aesthetic manipulation of light and movement, for instance, was central to the Groupe de Recherche d'Art Visuel (GRAV), founded in Paris in 1960. Here we find a Constructivist leaning towards a depersonalised approach, machine-like precision, a desire for a greater degree of collaboration with the spectator, for a more scientific attitude towards art and a belief in its potential universality. This last was firmly upheld by one of GRAV's most energetic supporters, Victor Vasarely, the Hungarian painter who had settled in Paris in 1930. He first adopted geometrical abstraction in 1947 and in the mid-1950s began writing a series of manifestos on the use of optical phenomena for artistic purposes. He became associated with the Galerie Denise René, and, owing to the visual ambiguities explored in his paintings and prints, he was soon recognised as one of the main originators of optical art, or Op Art, as it became called. Riley knew of Vasarely but did not meet him until she herself was well established as an artist. They argued over universality in art, Vasarely believing that this would be achieved through the multiplication of imagery made possible by mass reproduction. Riley disagreed: if an artist is fortunate enough to touch the universal, she said in a conversation with Vasarely, the test would lie in the quality of the work itself rather than in the quantity of the images produced. Instancing a work that achieved universality, she quoted Van Gogh's *Sunflowers*.

Throughout these early years, Riley, through her connections with other artists, thinkers and writers, through her reading and growing familiarity with past art, was steadily building a raft of ideas and sensations on which to float her own pictorial language. One transfiguring experience in the

summer of 1960 had been caused by a sudden squall in Venice. Riley watched as rain drove its way over black and white paving in a piazza. Her attention was seized by the way in which the veil of water dissolved the pattern of the stones. The downpour did not last long and, as the weather was hot, the stones steamed and dried and the clarity of the pattern soon returned. But this consciousness that the equilibrium within a rigid structure could be disturbed and then restored stayed with her, and within a year or two had begun to appear in her work.

In the autumn of 1960 came a fresh personal crisis. Riley's close association with de Sausmarez ended, and, although they remained friends, the difficult feelings associated with this change in relations momentarily led her to conceive of abandoning art. She had been toying, like other of her contemporaries, with Hard Edge abstraction and decided to paint one final, entirely black picture. She did so and was disappointed to find that it did not express all the emotional energy she had invested in it. The question – what is wrong with it? – brought the realisation that it contained no contrast, that it was not in itself divided or had any opposition within it to give it life.[19] She therefore decided to paint one more picture in which she not only offset a straight line with an off-centre curve but also introduced the contrast of white against black. Where the descending black curved shape, as it approaches the black rectangle filling the lower half of the canvas, exerts the most pressure on the intervening area of white, squeezing it into a thin line, a sudden flash of light occurs. This not only gave rise to the title – *Kiss* – but was the small, startling optical dynamic that proved to be the origin of Riley's pictorial identity.

The question – why has this happened? – was to be a recurrent one as she began to explore optical relationships within a formal geometrical framework. From *Kiss* she moved on to the first of two paintings called *Movement in Squares* in which the chequer-board squares gradually diminish in width, thereby heightening the frequency at which the eye has to register the black and white contrast. At the point of climax, where the units are most tightly clenched, the picture surface appears to buckle inwards, while the agitation created in the eye's retina causes this part of the image to vibrate, the painting as a whole offering contrasting states of tension and release.

With these two paintings she established a principle that was to act as a staple ingredient in her work over many years:

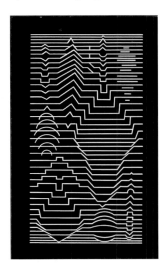

Victor Vasarely
Méandre V (1 057)
c.1950
Acrylic on wood
Galerie Denise René, Paris

19. This passage paraphrases Riley's own words as used in a lecture on her work given at Abbot Hall Art Gallery, Kendal, 19 January 1999.

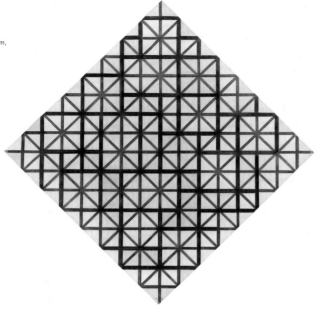

constancy against inconstancy, one aspect of the structure, such as the horizontal divisions in *Movement in Squares*, remaining fixed, while another changed. She began to look for this principle in other art, finding it, for instance, in Mondrian's *Composition with Grid* (1918) where the grid remains constant while the lines thicken and thin and planes emerge and recede. This principle, of something simultaneously constant and varied, was essential to the portrayal of movement, for the suggestion of shift or progress required an underlying stasis. From here onwards, it was a journey of increasing sophistication in her handling of black and white relationships, as she alternated fast with slow movement, leading the eye along a definite path or setting up crosscurrents, and at other moments, as in *Shiver* and *Tremor*, causing movement to happen all over the picture surface. In *Fall* and *Crest* an intense point is reached where the falling curves, initially slack and full of lassitude, are suddenly compressed, the switches in direction creating a horizontal visual disturbance that challenges the downward movement of the curves. In other paintings, such as *Pause* and *Burn*, the addition of a tonal contrast, as the elements move from darkest black to palest grey, enabled Riley to combine sweeping movement with dazzling effects of light.

Riley's steady increase in recognition, as her work appeared in exhibitions and became the subject of critical appreciation in the art press, is not part of this essay. But

mention must be made of *The Responsive Eye* exhibition held at the Museum of Modern Art, New York, in 1965, as this broad survey of a contemporary interest in perceptual abstraction included enough instances of art which shocked or disrupted vision through the use of optical devices or perceptual ambiguities to give rise to the term Op art. It also marked the onset of Riley's international reputation, for it coincided with her solo exhibition at the Richard Feigen Gallery, which – unusually for an English artist exhibiting in New York – sold out before the opening. With her painting *Current* on the cover of *The Responsive Eye* catalogue, Riley was swiftly identified as a key figure within the new development which the curator William C. Seitz saw as the intent 'to dramatize the power of static forms and colours to stimulate psychological responses'. [20]

The idea behind the *Responsive Eye* exhibition had initially been announced in November 1962. At that time Seitz had the idea of showing the development of perceptual art from Impressionism to the most recent optical painting. But in the intervening period the proliferation of painting and construction employing perceptual effects was so rapid that the demands on gallery space did not leave room for a retrospective view. Seitz did not confine his attention to any single tendency, group or country, but included work by groups and individuals representing tendencies in fifteen countries. Thus Riley's work was positioned within a very mixed representation of recent art, including, for instance, reliefs and line constructions by Jesus Rafael Soto and Gerald Ostler, optical paintings by Vasarely and Benjamin Frazier Cunningham, and large heraldic canvases by Morris Louis and Kenneth Noland. In the catalogue Seitz argued that 'the perceptualism of the present . . . is more concentrated than that of impressionism because the establishment of abstract painting has made it possible for colour, tone, line, and shape to operate autonomously.' His analysis of certain effects of movement and illumination concluded with the remark: 'the impression of brightness and pulsation can reach a startling intensity. The eyes seem to be bombarded with pure energy, as they are by Bridget Riley's *Current*.'

With hindsight, we can see that this interest in optical effects had a wider context, for perceptualism played a key role in post-war debates about philosophy, psychology and art, in England, America and France. In an address, summarising and defending his *Phenomenology of Perception*, shortly after its publication in 1945, Merleau-Ponty insisted

20. William C. Seitz, *The Responsive Eye*, The Museum of Modern Art, New York, 1965, p. 41.

that 'the perceived world is the always presupposed founda-
tion of all rationality, all value and all existence'.[21] He was to
identify the perceiver not as a pure thinker but as a 'body-
subject', implying that some pre-logical form of knowledge
or consciousness is incarnate in the body and inheres in the
world.[22] Likewise, the Existentialists focused on the actual
human situation as the starting point for any authentic phi-
losophy, emphasizing the fact that we are situated partici-
pants in a continuous, open-ended, socio-historical drama,
and that it is necessary for us to have a keen awareness of our
freedom and responsibility in shaping the situation in which
we are already involved. Awareness of these theories led
Maurice de Sausmarez to write of Bridget Riley in 1970: 'In all
that she does she declares herself a true descendant of the
phenomenologists, rejecting pre-suppostions (theoretical or
habitual) and looking for the extension of her knowledge
through the direct engaging of her senses and her total
consciousness.'[23]

It was not, however, Merleau-Ponty's key work, the
Phenomenology of Perception, that had direct relevance to
Riley's thinking, but his essay 'L'Oeil et l'esprit', which, in
translation as 'Eye and Mind', was included in his The Primacy
of Perception and Other Essays, published in 1964. An
entire thesis could be constructed on the relevance of this
essay to Riley's art. Suffice it to say here that in questioning
the enigma of vision, Merleau-Ponty stressed how phenom-
ena derived from our perception of space – such as orienta-
tion, polarity, envelopment – are always linked to our being
or presence. It is not enough to think in order to see, he
argued: 'Vision is a conditioned thought; it is born "as occa-
sioned" by what happens in the body; it is "incited" to think
by the body.'[24] His insistence that we look out from the
inside has relevance not only to the painter but also the viewer.
'Things have an internal equivalent in me,' he writes, 'they
arouse in me a carnal formula of their presence.'[25] And
because of this two-way relationship, between the see-er
and the seen, within a body which opens its self to the world,
it makes little difference if the artist does not paint from
nature, for 'he paints, in any case, because he has seen,
because the world has at least once emblazoned in him the
ciphers of the visible.'[26] In this and other ways, Merleau-
Ponty may have reinforced the corporeality of Riley's art and
licensed its relation, not to an idealised, disembodied specta-
tor, but to a viewer, immersed in the world, in whose body is
an intertwining of vision and movement. Equally significant

is Merleau-Ponty's metaphysical notion that the painter
does not impose her or his view on the outside world: 'The
world no longer stands before him through representation;
rather, it is the painter to whom the things of the world give
birth by a sort of concentration or coming-to-itself of
the visible.' The painter goes beyond representation, breaks
through the '"skin of things" to show how the things become
things, how the world becomes world'.[27]

Among art theorists and historians, the study of percep-
tion helped change ways of looking. Perceptual analysis rich-
ly informs the early art historical writings of E.H. Gombrich;
found a vital outlet in Anton Ehrenzweig's The Hidden
Order of Art (1967), which introduced a psycho-analytical
approach to the study of aural and visual perception; and
fired Rudolf Arnheim to write his seminal book, Art and
Visual Perception (1954), at headlong pace over fifteen
months. Like others, Arnheim was greatly indebted to
Gestalt psychology which derived scientific principles from
sensory information and stressed the importance of the inte-
grated structure of the whole: only within the overall pattern
was it possible to determine the place and function of each
element. The same principles had been shown to apply to
various mental capacities, so that, it was argued, seeing, far
from being a mechanical function, involved a creative appre-
hension of reality. Thus looking at the world required, as
Arnheim pointed out, 'an interplay between properties sup-
plied by the object and the nature of the observing subject'.[28]
Since then neurologists have evolved increasingly complex
theories of vision in an attempt to explain what happens
when the eye and mind are engaged in looking, proving
incontrovertibly 'the awe-inspiring complexity of vision'.[29]

The issue of perceptualism gained urgency with the
revival of interest in abstraction, for without the mask of rep-
resentation artists needed to find some other framework for
their art. 'The artist of today', Paul Klee had written, 'is more
than an improved camera; he is more complex, richer and
wider.' When Klee's Notebooks: Volume I: The Thinking
Eye appeared in translation in 1961, it rapidly became a cult
book, and was read by Bridget Riley soon after it was pub-
lished. Made persuasive by the fact that Klee's theoretical
discussions and analyses were accompanied by illustrations
of his own work, which further elucidated his ideas, the book
showed the logic of plastic thinking that can underpin an
artist's distillation of pure formal relations. Klee not only
taught painters how to 'take a line for a walk', but made

21. Maurice Merleau-
Ponty, The Primacy
of Perception, op. cit.,
pp. 160-61.

22. 'My act of
perception, in its
unsophisticated form
. . . takes advantage
of work already done,
of a general synthesis
constituted once and
for all, and this is what
I mean when I say that
I perceive with my
body or my senses,
since my body and my
senses are precisely
that familiarity with
the world born of
habit, that implicit or
sedimentary body of
knowledge.' Maurice
Merleau-Ponty,
Phenomenology
of Perception,
translated
by Colin Smith,
London: Routledge
& Kegan Paul, 1981,
p. 238.

23. Maurice de
Sausmarez, Bridget
Riley, op. cit.,
pp. 87-88.

24. Merleau-Ponty,
'Eye and Mind',
translated by
Carleton Dallery in
The Primacy of
Perception, op. cit.,
p. 175.

25. The Primacy of
Perception, ibid.,
p. 164.

26. Ibid., p. 166.

27. Ibid., p. 181.

28. Rudolf Arnheim,
Art and Visual
Perception:
A Psychology of
the Creative Eye:
The New Version,
University of
California Press, 1974,
p. 6. Originally
published in 1954.

29. This quotation
comes from a
conversation
between Riley and
E.H. Gombrich
(Dialogues on Art,
op. cit., p. 43) in which
Gombrich alludes to
the discoveries of
certain neurologists as
to how various parts
of the brain react to
colour, to shape and
to movement and
how these systems
interact in surprising
and bewildering
ways, 'so that what
another student of
vision, J.J. Gibson at
Cornell, called "the
awe-inspiring
complexity of vision"
has by now become a
scientific fact.'

movement a central aspect of his thinking about form. For Riley, Klee was crucially important as a thinker, builder and maker of art. 'Seurat, Paul Klee and the Futurists were my roots,' she has put on record. 'Particularly Klee. In the 1960s I had the opportunity to explore what those forms and lines and colours could do when they no longer had to describe anything. I wanted to discover their own character.'[30]

The notion that art is in essence constructive is implied in everything Klee wrote and was openly stated by Stravinsky in his *Poetics of Music*.[31] This series of lectures which Stravinsky delivered at Harvard University forms another of the books which Riley has indicated had particular importance for her.[32] In this instance she may have read Stravinsky less for direction than for confirmation of the stance she herself had already adopted. Stravinsky firmly upholds the necessity of order and discipline. 'The more art is controlled, limited, worked over, the more it is free,' he argues.[33] And elsewhere: 'Let me have something finite, definite – matter that can lend itself to my operation only insofar as it is commensurate with my possibilities. And such matter presents itself to me together with its limitations. I must in turn impose mine upon it. So here we are, whether we like it or not, in the realm of necessity . . . in art as in everything else, one can build only upon a resisting foundation . . . My freedom thus consists in my moving about within the narrow frame that I have assigned myself for each of my undertakings. I shall go further: my freedom will be so much the greater and more meaningful the more narrowly I limit my field of action and the more I surround myself with obstacles. Whatever diminishes constraint, diminishes strength. The more constraints one imposes, the more one frees one's self of the chains that shackle the spirit.'[34]

When Bridget Riley began using colour the most obvious constraint was the limitation in hue. The magisterial effect of *Late Morning* is achieved through vertical paired stripes of red, green and blue, where the combination of colour interaction with the high frequency of the small white interval between the coloured bands sets up a terrific energy and beat. The realisation that purely visual relationships can bring about powerful sensations led on to *Rise*, where the horizontal emphasis set up by the tripartite stripes (composed of green, lilac and red in varying order) is counterpoised with alternating warm/cool effects created by the oranges, yellows and greys which bloom from the canvas like a rising mist. Here, as Bryan Robertson has written, we

encounter 'an art of perception, made concrete by conceptual speculation,' in which, as he goes on to argue, 'the imaginative qualities of the painting radiate beyond that optical encounter and pass through to another dimension.'[35]

That other dimension is never illustrational. Though Riley's titles, such as *Deny* and *Arrest*, often link her pictures with psychic or physiological sensations and in some instances suggest analogies with music or dance, these associations are echoes rather than intrinsic. *Tremor*, for instance, with its delicate overall suggestion of movement, has a quivering quality similar to that which the wind stirs in the leaves of a tree. In her choice of title, Riley acknowledges that potential link, but the sensation created by the painting goes beyond any specific or fixed allusion. And when making her early black and white paintings, Riley was too involved with perceptual discoveries to look for such resonances. 'For quite a long time,' she has recalled, 'I was embarrassed by using the word "I" . . . in relation to my work – I much preferred to say "one", because I felt this thing, the medium, was so strong and rich that I was just an agent who caught the various inflections and allowed them to play their own thing – freely.'[36]

But if for Riley the meaning of a work of art remains immanent, she recognizes that it is also a structure through which we can reach past echoes and experiences. Her reading of Merleau-Ponty may have alerted her to the need to re-examine the relationship between past and present, for in his definition of the past, not as a conglomeration of sensations and memories, but as a 'horizon' or 'atmosphere' or 'field' which 'envelopes' the present, he was asserting that an inherently meaningful present experience at every moment has access to a past. Whether or not this recognition came from Merleau-Ponty, it was abundantly proven by her reading of Proust. Riley's introduction to this author came through Samuel Beckett. As his short monograph on Proust reveals, Beckett had only qualified admiration for *A la Recherche du Temps Perdu*, but he was abundantly interested in Proust's use of involuntary memory, in the negation of time and in Proust's pessimism.[37] Beckett's brilliant analysis of what makes involuntary memory so powerful leads him to the following conclusion:

The identification of immediate with past experience, the recurrence of past action or reaction in the present, amounts to participation between the ideal and the real, imagination and direct apprehension, symbol and

30. *Independent*, 30 August 1994. Riley also acknowledges the importance of Klee's *The Thinking Eye*, in *Dialogues on Art*, op. cit., p. 34.

31. Igor Stravinsky, *Poetics of Music*, Oxford University Press, 1947, p. 11.

32. See note 14.

33. *Poetics of Music*, op. cit., p. 63.

34. Ibid., pp. 63, 64-65.

35. *Bridget Riley: Paintings and Drawings 1951-1971*, op. cit., p. 8.

36. *Bridget Riley: Paintings and Drawings 1961-73*, Arts Council of Great Britain, p. 11.

37. Beckett's interest in Proust also lay in the fact that he was one of the authors who encouraged his search for 'an intellectual justification of unhappiness'. See Beckett's letter to Tom MacGreevy as quoted in James Knowlson, *Damned to Fame: The Life of Samuel Beckett*, London: Bloomsbury, 1996; 1997, paperback edition, p. 118.

substance. Such participation frees the essential reality that is denied to the contemplative as to the active. [38]

Riley began reading Proust in 1974, after Bryan Robertson gave her the first four volumes of C.K. Scott Moncrieff's translation. She also began making regular visits to Cornwall, owing to her mother's final illness. The long train journeys, to a part of England where she had spent a significant part of her childhood, not only carried her back in time but also echoed Proust's imaginary world. The fascination of the book can be so intense that it is difficult, on first reading, to see the relationship of the parts to the whole, to appreciate the thematic links and connecting episodes and to separate the underpinning philosophy from the narrative. Riley, on reaching the end of the novel, began reading it again, making, for her own purposes, a summary of the text, with the notion of extracting from this a lexicon in which would be listed all the various insights out of which Proust wove his creative vision. Though this project was abandoned when she reached the end of *Swann in Love*, both summary and lexicon attest to her desire to assimilate Proust at a deep level.[39]

For Riley, one of the fascinations offered by Proust may have been the constantly shifting nature of his imagery: the places he describes, the characters, situations, small epiphanies, obsessive emotions and patterns of behaviour are never presented in fixed and definite form, but reveal new aspects and invite different interpretations as the story unfolds and the revelations accumulate or the point of view of the observer changes. As Edmund Wilson has written: 'The conviction that it is impossible to know, impossible to master, the external world permeates his whole book.' [40] Like Jackson Pollock's paradoxical achievement of stillness within a concentrated network of flung lines, Proust's novel contains change within apparent immobility. Impressed by the power of Proust's imagination, Riley has observed that the book seems to chart 'the entire process of creativity', and that a possible key to the power of Proust's imagination lies in the remark made by the painter Elstir in the final volume – that we must renounce what we love in order to recreate it. [41] But on first reading Proust, the encounter with his imaginative journey back in time to his childhood may have fostered in Riley a similar retrospective mood, enabling her to rediscover the extent to which she had internalised the Cornish coastline. First taught the pleasures of looking while walking along the cliffs with her mother, she now recognised that

many of these experiences had formed the basis of her visual life. In 1984 she wrote about them at some length in a catalogue to the exhibition *Working with Colour*.[42] Lyrical and intense, the experiences listed include violent contrasts, unexpected colour relationships, sudden switches in the direction and layering of landscape and the glittering, ever-changing surface of the sea – 'the entire elusive, unstable, flicking complex – subject to the changing qualities of the light itself'. The revelatory content of this article invites the conclusion that Riley's paintings, not only those included in this show but also those made in the last twenty years, reach through, consciously or unconsciously, to echoes and allusions that accrued in her childhood.

At one point in *A la Recherche du Temps Perdu* Proust holds up, as a token of artistic integrity, the little patch of yellow wall in Vermeer's *View of Delft*, which the writer Bergotte, overcoming his reclusive instincts brought on by ill health, goes to see. Though made giddy by the effort, he fixes his eye on this little patch of yellow. '"That is how I ought to have written," he said. "My last books are too dry, I ought to have gone over them with several coats of paint, made my language exquisite in itself, like this little patch of yellow wall."' [43] A little further on Proust unfolds thoughts on the possibility of immortality and asks what 'burden of obligations' caused Bergotte and Vermeer to create. 'All these obligations', he concludes, 'which have not their sanction in our present life seem to belong to a different world, founded upon kindness, scrupulosity, self-sacrifice, a world entirely different from this' [44]

Riley herself has often gained encouragement by looking at other artists. Her involvement with the Old Masters found a fruitful outlet in 1989 when the National Gallery asked her to select one of the *The Artist's Eye* exhibitions. All the paintings that she chose were large, complex compositions which brought together a number of figures, most in motion, in a dynamic shifting pattern which led the eye in a variety of directions. The link with her own work was revealed in the catalogue where, in conversation with Robert Kudielka, she related the organisation of colour to the compositional movement. But in all the various aspects of her career, including her involvement with the 1997 Mondrian exhibition at the Tate Gallery, her lectures on colour and painting, her contributions to television documentaries on art, her dialogues originally produced for radio, and in the steady unfolding of her own work, she has promoted a better

38. Samuel Beckett, *Proust,* New York: Grove Press, 1931, pp. 55-56.

39. Both summary and lexicon remain in the artist's possession.

40. Edmund Wilson, *Axel's Castle: A Study in the Imaginative Literature of 1870-1930,* London: Penguin Books, 1993, p. 156.

41. See Riley's remarks in conversation with Bryan Robertson, in *Dialogues on Art,* op. cit., p. 87 and p. 89.

42. 'The Pleasures of Sight', reprinted in *The Eye's Mind,* op. cit., p. 30.

43. Marcel Proust, *The Captive: Volume Nine of Remembrance of Things Past,* translated by C.K. Scott Moncrieff, London: Chatto & Windus, 1968, p. 249.

44. Ibid., pp. 250-51.

understanding and appreciation of creativity in all its complexities and difficulties, as well as its pleasures. 'The first merit of a painting is to be a feast for the eye.' So Delacroix wrote in his *Journals,* which remains another of Riley's key texts.

She has shown how, in Merleau-Ponty's words, 'the uncertain murmur of colours can present us with things, forests, storms – in short the world.' [45] When she rings to alter the time of an appointment owing to 'a colour problem', one subsequently discovers that it was the fractional alteration of tone in a cream or blue that was of such burning urgency. Not surprisingly she reads Jack Flam's collection of Matisse's writings with enjoyment, glimpsing the spirit of this great colourist through his words as well as his art. She also delights in Baudelaire's swingeing attacks on sloppiness and vulgarity in his Salon reviews, [46] and quotes with pleasure Rilke's mention of 'the good conscience of these reds, these greens' in Cézanne's paintings. [47] It is, Rilke comments, faced with the colossal reality of Cézanne's art, 'as if these colours could heal one of indecision'. [48] Something similar can be felt in front of Riley's art, for a rare certainty underlies her willingness to take extreme measures; to look for the shifting, the unexpected and evanescent, and to find a stringent plenitude.

45. *The Merleau-Ponty Aesthetics Reader, (Philosophy and Painting),* Galen A. Johnson, et al., Northwestern University Press, 1993, p. 133.

46. Collected in Charles Baudelaire, *Art in Paris 1845-1862 : Salons and Other Exhibitions*, ed. Jonathan Mayne, London : Phaidon Press, 1965.

47. Rainer Maria Rilke, *Letters on Cézanne*, ed. Clara Rilke, London : Jonathan Cape, 1988, p. 50.

48. Loc. cit.

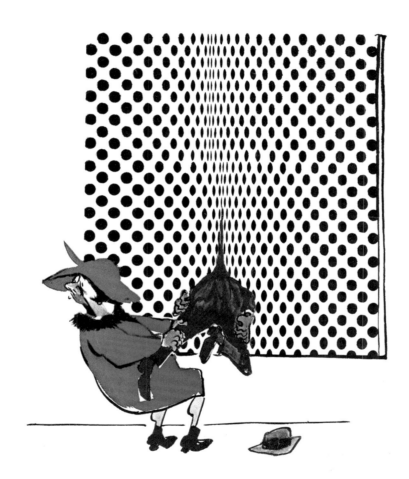

Erich Sokol
Cartoon
1965

BUILDING SENSATIONS
THE EARLY WORK OF BRIDGET RILEY

Robert Kudielka

We find certain things about seeing puzzling, because we do not find the whole business of seeing puzzling enough.[1] — LUDWIG WITTGENSTEIN

During the winter of 1998-99, Abbot Hall Art Gallery in Kendal mounted a small retrospective of Bridget Riley's work. In the first room many of her celebrated black and white paintings of the early sixties, such as *Movement in Squares*, *Blaze 4* and *Pause*, were brought together. It was interesting to see the curiosity and circumspection with which the public approached these works. People spent a considerable length of time looking and comparing, reading the catalogue and pointing things out to each other, returning to certain paintings and changing their place of viewing. Young people seemed impressed and some of the elderly visitors went up close, lifting their spectacles to see more clearly what they were looking at. No one in this gathering behaved as though they were in any way threatened or in imminent danger.

Some thirty years ago the general attitude to Riley's work was quite different. Even those who were open-minded and prepared to encounter a new experience could not help being affected by the fashionable view of what they were going to see. In 1965, at the height of the excitement surrounding *The Responsive Eye* exhibition at the Museum of Modern Art in New York, which launched Riley's reputation, the contemporary art world seems to have been engaged – partly innocently, partly deliberately – in generating a peculiar sort of myth. Riley's work became the centre of a critical tale of violence and aggression inflicted on the spectator by so-called Optical art, and this view persisted right through the seventies. Even supporters called her paintings dazzling or blinding, relating the experience to states of hallucination and 'feeling high'; the majority, however, denounced them as mindless, nauseating and detrimental not only to the standards of art, but almost physically harmful. Erich Sokol, the cartoonist, put his finger on this hysteria when he drew a woman desperately trying to save her husband from being sucked into the centre of Riley's painting *Fission*.

It could be said that the composure of today's spectators merely demonstrates that the novelty of the work has worn off. But this would mean that the effect was never merely physical, and makes it even more interesting that people who now see the paintings for the first time seem to be quite at ease with them. It is also beside the point to claim that the artist herself has paved the way towards a more balanced response by refraining in later paintings from the violence of her early pieces. Although the element of instability in Riley's work has undergone several transformations since she moved from her black and white paintings to her present preoccupation with colour, the tension between structural firmness and shifting perceptions, so particular to her, has remained remarkably constant. Both these rationalisations are inadequate because they overlook the beginning of Riley's public career. Following her first solo exhibition at Gallery One in London in 1962 she rapidly gained a certain measure of international recognition without which she would never have been invited to participate in *The Responsive Eye* exhibition; and during these three years there was no review complaining of 'eye-bashing', although the disturbing factor built into her work was observed right from the beginning. In his review of the show at Gallery One, David Sylvester clearly saw this quality and recognised its balance within the work:

> *The disturbing element is not only imaginative in conception but has the sort of rightness in its placing that a good actor has in his timing – it seems at once unexpected and inevitable. This proposing and disposing of order seems no mere game with optical effects, it seems to symbolise, dramatically, an interplay between feelings of composure and anxiety.*[2]

In drama and the other arts, the sensation of unstable situations and identities shifting between disruption and

1. Ludwig Wittgenstein, *Philosophical Investigations*, translated by G.E.M. Anscombe, Oxford University Press, 1989, p. 212e.

2. David Sylvester, 'Bridget Riley', in *New Statesman*, 25 May 1962.

23

restitution is well-established and accepted as a viable 'imaginative' equivalent to life. So why was this recognition denied in painting? With hindsight it is clear that the exhibition *The Responsive Eye* coincided with the start of the controversy between Minimalism and Modernism in American art.[3] Visual complexity did not suit either camp. Riley's paintings were aesthetically too energetic and demanding to fulfil the need for 'disinterested contemplation' which Clement Greenberg had put forward as the historical role of Abstraction in his essay 'The Case for Abstract Art' (1959).[4] Conversely, the intricacy of her structures must have looked to the partisans of 'holism' and 'non-composition' like the epitome of that 'fussiness' (Frank Stella) and 'juggling' (Donald Judd) which they associated with European art.[5] It was the current taste for blandness and vacancy – post-painterly or conceptual – which could not help but feel challenged and confused by Riley's work.

Thirty years later the situation has certainly changed, although it has not necessarily led to a more appropriate understanding. Ironically Bridget Riley now figures, for many of her new admirers, as the 'last Modernist' in painting as though her work had never been condemned as a deviation from the Road to High Art. It is time to lay aside these various clichés and try to see Riley's work in its own terms. The exaggerated attention paid to its 'effect' has obscured its true character for far too long. There is an astonishing lack of plain observation in the reviews and appreciations of the past twenty years. Talking about the 'blinding' quality of the work has become a licence not to bother with it any further and prevented a long overdue rediscovery. None of Riley's paintings have been created to bring about an optical effect as such; they are built, with a unique inventiveness and ingenuity, to house that particular sensibility for disruption and instability which is all her own.

An equilibrium at risk

There was no such thing as Op art when Bridget Riley first showed her paintings. The opening sentence of Sylvester's review states: 'Bridget Riley is a hard-edge abstractionist.' The big, flat, sharply delineated areas of *Kiss* (1961), fully justify this classification. Of course, the elusive optical flash at the point where the curvilinear shape almost touches the straight form beneath seems to herald further developments. But this harbinger can easily divert attention from a

Bridget Riley
*Study for
'Broken Circle'* 1963
Ink and pencil collage
on paper
Private collection

more important aspect. Being based on a square format the unequal division of forms and masses in *Kiss* lays out the ground plan of Riley's earliest pictorial order.

Traditionally painters have tended to avoid working within equal dimensions because it does not give a bias from which to start. But for this very reason Riley seems to have chosen the square as the basic format for most of her paintings right up to 1967. It provided a static equilibrium which could be upset by asymmetrical divisions. In *Kiss* the total field is divided twice, horizontally as well as vertically, each time in a ratio of approximately two to one. The edge of the straight form delineates the horizontal division whereas the near touching point of the large curved shape above indicates the hidden vertical.

The recurrence of such bisections in later paintings shows that there is no mathematical system behind it. Although some of the measurements may come close to the Golden Section, they are not established by that proportional device. Nevertheless there is a certain range within which these divisions are positioned whether they are horizontal or vertical. Either the proportions are clearly irregular as in *Kiss* and *Cataract 3*, in *Movement in Squares* and *Pause*; or these divisions are just off centre, narrowly avoiding symmetry, as in *Serif*, *Crest* and *Current*. Furthermore, there is another option which refines the use of this destabilising factor. Instead of being apparent the asymmetrical disposition can be hidden, as in *Black to White Discs*, *Breathe*, *Arrest 2* or *Cantus Firmus*. Such latency heightens the sensation of a given equilibrium at risk.

As Riley developed her means an important extension to this structural device emerged that is still effective in her

3. Although from today's point of view Minimal art is subsumed into 'Modernism', this was not so at the time. The supporters of Clement Greenberg's view of the evolution of Modern art were opposed to the claims of the Minimalists, as one can see from Michael Fried's essay 'Art and Objecthood', 1967. One of the critical points was the notion of 'presence', whether the picture plane was an area in its own aesthetic right or simply a physical fact among the other objects existing in the world. The whole debate is well documented in *Minimal Art: A Critical Anthology*, ed. Gregory Battcock, London: Studio Vista, 1969.

4. Clement Greenberg, *The Collected Essays and Criticism*, ed. John O' Brian, 4 vols, University of Chicago Press, 1986-93, vol. IV, p. 80.

5. 'Questions to Stella and Judd', interview by Bruce Glaser, 1964, ed. Lucy R. Lippard, 1966. In *Minimal Art*, op. cit., p. 150.

recent work. In circular compositions such as *Uneasy Centre* and the *Blaze* paintings the axial asymmetry has been turned into a displacement of the centre. But as the few remaining preparatory drawings for these works show, this displacement can take on a wider role. In the *Study for Broken Circle* (1963), for instance, the coherent form of the circle is dismembered and reassembled in a new way. This treatment can also be found in *Fission*, where two different formal progressions, one long and one short, are displaced cross-wise so that a tension arises which gives the painting its name. From about 1963 onwards dislocation becomes a basic building practice in Riley's work, independent of formal changes and even of the move into colour. For instance, in *Where* the tonal movements are dislocated in such a way as to form a regular tripartite structure which recurs in different forms in later paintings. Eventually this principle of breaking up a given unity and reassembling it encompasses both ends, as it were, of the building process. In the paintings which Riley began in 1986 the continuity of the vertical bands is broken up by a diagonal, and this upheaval is counteracted and rebalanced by the dislocation of the rhomboid colour forms it produces.

This later development emphasizes that destabilisation and disruption in Riley's work is never an end in itself but a crucial step in transforming a static equilibrium into a dynamic one. A stable position is turned into a balance between stability and instability. It is obvious, however, that on the basis of *Kiss* alone it would not have been possible to push ahead with considerations of such extreme abstraction. *Kiss* shows only the ground plan of Riley's pictorial world, the means and methods to construct it still had to be found.

Bridget Riley
Ease 1987
Oil on linen
Private collection

Progressions – formal and tonal

There were only a few early paintings done in a similarly intuitive manner, among them *Horizontal Vibration* (1961) and *Serif* (1964). Both are characterised by areas of compression and expansion achieved through the varying widths and intervals of the black and white bands, and it is clear that *Serif* is a kind of reprise prompted by the curve painting *Crest*. In 1961 Riley had already begun to look for a structure that would allow her to articulate and develop her interests more satisfactorily. The discovery took her by surprise. While working on a sequence of black and white squares she suddenly found that by steadily diminishing their widths she could generate a movement, and in one long working session, as she remembers, she completed *Movement in Squares* (1961), the only painting done in such bravura manner.

The progressive structure of this painting could look like an abstract version of a Futurist depiction of movement, and Riley's earlier interest in Futurism – particularly in Giacomo Balla – seems to confirm this connection. But there is an essential difference. *Movement in Squares*, and all subsequent paintings using progressive sequences of form and tone, does not represent movement in its successive phases, but enacts it autonomously in the picture plane. That is to say, we perceive these sequences as movement, rather than reading them as chains of incident, because they are pitched against a constant. With *Movement in Squares*, Riley discovered for herself the plastic principle that in order to define an experience she had to bring in its opposite. The squares 'move' because, while their widths decrease, their heights remain the same.

However, this progressive reading precipitates yet another kind of movement, a sudden dissolution which periodically engulfs the entire pictorial field. It is as though the accumulation of tension in the compressed zone leads to a momentary flash or disturbance. But this disruption is never final, it is held in check by the overall structure. Stability is regained, only to be challenged again, in what seems to be a cyclic process. In 1965 Riley herself described this momentum:

> The basis of my paintings is this: in each of them a particular situation is stated. Certain elements within that situation remain constant, others precipitate the destruction of themselves by themselves. Recurrently, as a result of the cyclic movement of repose, disturbance and repose, the original situation is re-stated. [6]

6. 'Perception Is the Medium' (1965), reprinted in *The Eye's Mind : Bridget Riley : Collected Writings 1965-1999*, ed. R. Kudielka, London : Thames & Hudson, 1999, p. 66.

This perceptual phasing, which E.H. Gombrich related to the periodical momentum of Western music,[7] reappears in many variations and guises throughout her work. But it is particular to the early black and white paintings that one can read the score, so to speak, before the performance starts. The spectator can survey the structure, distinguish and perceive the progressive sequences, and yet is still drawn into the cadence with which the cycle begins again.

In *Fission* (1963) the character of the performance is changed according to the different structural potential of the chosen element. The progression of a circle to an oval is read in reverse as an expansion towards the full form, and because the units do not touch, as the squares did, the whole field behaves differently. The distress caused by the rupture of the vertical axis is 'healed' by long looping arcs which curve diagonally across the canvas. Because of this greater flexibility the sequence of circles to ovals proved to be one of the most fertile themes in Riley's repertoire. As *Where* and *Pause* (both 1964) show, the formal progression can be combined with tonal sequences from light to dark, to create more subtle and complex sensations.

Tonal progression was first introduced as a theme on its own in *Black to White Discs* (1962), Riley's largest canvas to date. The painting accommodates a centrally placed diamond of evenly spaced identical discs which advance and recede according to a successive modulation of tone. Although the fullest sequence from the palest grey on the left to the black is longer and slower than its reverse on the right, the suggestion of symmetry is so strong that the eye tends to cling to the vertical centre of the diamond until one discovers that the true tonal centre of the image, the line of absolutely black discs, is just a little to the right. Such veiled, subliminal moves play an important part in the fabric of Riley's paintings right through to the present day. But in her early studio practice this tonal structure also lent itself to a kind of cross-breeding with formal progressions, resulting in a method of differentiating visual time.

Where and *Pause* are both about the modification of a basic formal movement through the different visual tempi provided by tonal sequences. In *Where,* two different gradations to and from a central grey – one quick, the other slow – are imposed on a regular structure of increasing and decreasing forms, with the result that the shifting paces completely change the character of the space. The underlying compression becomes almost explosive, and only the dislocation of

the tonal sequences relieves the tension. *Pause* is a much more mysterious painting. Here the shift of tempi veils the structure altogether. As so often in Riley's work a clue is given at the top and the bottom of the painting, because even in contriving the most elusive and enigmatic sensations she remains a builder, erecting a painting rather than inscribing it on a flat surface. Along both edges one can see that the two tonal movements from black to the palest grey – one in thirteen and the other in seven stages – do not converge with the formal structure which clearly echoes that of *Movement in Squares*. By turning these sequences inside out as they travel down and across the painting, the absolute black circle in the top left corner becomes the slimmest oval in the compressed area at the bottom. In reverse, the palest grey circle at the bottom right moves up through the compression turning into an oval just off centre at the top. And yet, however rigorously these concerted movements may be fashioned, they eventually combine to form a light and serene divertimento.

With such complex organisations the stable starting point of the original scenario was slowly eroded giving way to an instant sensation of flux and motion. This development is most apparent in a group of paintings employing a device which in Riley's studio parlance is called 'point movement'. Their archetype is *Shift* (1963). The scale study reveals how the triangles are brought about. A regular vertical and horizontal register provides a constant proportion of width and height while the moving points of the triangles are established by a crossing diagonal. It may be noted that this is already a step from the progressive phrasing of single units towards the organisation of a total field. But in the actual

Bridget Riley
Scale Study for 'Shift'
1963
Gouache on paper
Private collection

7. *Bridget Riley : Dialogues on Art,* ed. R. Kudielka, London : Zwemmer, 1995, p. 42.

painting the literal scenario of the 'cyclic movement of repose, disturbance and repose' can still be recognised. The points of the black triangles in the vertical compartments move progressively in one direction, then turn, and finally return back into the original direction. The key-units for this organisation are the rectangular triangles. They can be seen along the top and the bottom of the painting, and they mark the turning-points within the structure. While the first change of movement drops steadily through the addition of one triangle each time, the return back into the original direction is increased by a ratio of two units. As a result the centre passage opens out like the segment of a fan until it spans almost half the height of the painting. Conversely the long return movement is gradually reduced to a succinct clause in the bottom right corner, one right-angle against another.

The two subsequent paintings however, *Shiver* and *Burn* (both 1964), can no longer be seen in this way. It takes close analysis to discover that the highly energetic field of shifting directions in *Shiver* is controlled through firm structural divisions also marked by rectangular triangles. The total structure is divided by a pair of V-shapes which together form a hidden chevron. In the enclosed area at the top all the diagonals of the point movement 'lean forward' and straighten up towards the middle, before swinging back to their original position. The central chevron area is made up of repeated parallel movements, all the same length and all 'tilting backwards'. The return in the lower part repeats the upper movement, but in reverse sequence, the diagonals 'tip downwards' from an almost upright position and straighten up again. But this description of the formal means of the painting conveys little of its sensation. *Shiver* is the pure visual equivalent for certain states of being. They may be identified with the actual title of the painting, but Riley remembers that at the time she was also thinking of the beaded skirts and rapid little movements of the Shimmy – a dance popular in the twenties.

It is the advantage of such rigorous formalism that it can structurally encompass a variety of meanings. Paradoxically this requires that the artist lays aside any direct interest in content, as Riley has shown in her recent writing on Bruce Nauman's formalism.[8] She was surprised that an artist of such different persuasion should in some of his best pieces employ literally the same formal procedures as she herself has done: repetition, reversal, dislocation, asynchronism,

and accumulation of density. The only criterion for the successful articulation of an experience seems to be the unadulterated response to the specific plastic conditions in hand. In *Burn* she has given a fine example of this secret of formalist expression. By turning the structure of *Shiver* on its head she upset the equilibrium, and in trying to counteract the dislocation of weight she introduced the two tonal movements diffusing the gravitational pull downwards. But in adding this further complexity it became apparent that the scale had to be changed to a coarser grain to withstand the intense dissolution of the field. The result is not only a different sensation, an expressive paradox like 'cold heat', but a painting that exposes a critical contradiction that had emerged in Riley's pictorial world.

Images and fields

As early as 1963, Norbert Lynton noted a divergence between two distinctly different groups of paintings in Riley's work: 'image paintings' and 'field paintings'.[9] The first group contains all the images using dislocated circles, like *Uneasy Centre* for example, and is epitomised in the *Blaze* paintings. They are among the most explosive structures that Riley invented, because they carry the principle of dislocation directly into the 'quintessential and most dramatic space of all', as Bryan Robertson remarked: 'the distance between the spectator and the canvas.'[10] Far from being merely a geometric form amongst others, the circle is seen as the mirror image of our focus in looking; and by dislocating this relationship Riley touches the core of our vision.

This is undoubtedly an iconoclastic act and it is not by chance that Anton Ehrenzweig, the great theoretician of iconoclasm in twentieth-century art, wrote one of the best analyses of Riley's early work.[11] But it should also be seen that there is a steady, consistent move after 1963 to open up the all too immediate confrontation between the eye and its mirror. Although the surprising smallness of many of Riley's early works is due to the fact that they can only function and display their potential when they are encompassed by our view, the development of the work in general, and in particular the theme of point movement, shows that Riley began to undermine this confinement. The concern with images gave way to a more open field organisation which she attributed at the time to the example of American painting: 'open space, shallow space, a multifocal space as in Pollock.'[12]

8. Bridget Riley, 'Nauman's Formalism' (1999), in *The Eye's Mind*, pp. 212-16.

9. Norbert Lynton, 'London Letter', in *Art International*, vol. VII, no. 8, October 1963, p. 84.

10. *Bridget Riley: Paintings and Drawings 1951-1971*, introduction by Bryan Robertson, London: Arts Council of Great Britain, 1971, p. 7.

By 1965 the conflict of orientation seems to have been resolved. The zig-zag theme which had been instrumental in the powerful impact of the *Blaze* paintings was finally concluded in *Descending* (1965), a classic field painting. In an even vertical register every other division is a curve which progressively traverses the painting in a slow, dropping movement; and the dislocation in the zig-zag fabric brought about by this irregular gradient is no longer tense and spasmodic, but a sharp and angular ripple across an open field.

It is interesting to see that this shift had already begun in 1963 with a theme that by-passed the main preoccupation with structural progressions. In *Fall*, *Current* and *Crest*, Riley articulated the sensation of a whole field simply by re-iterating and amassing a particular curve. The only other structural devices are the irregular proportions governing the areas of contraction and expansion. Even more than the complex edifices of *Pause* or *Shiver* these repetitive structures, despite their graphic firmness, generate an immediate sensation of flux. Particularly in *Current* (1964) one can see the new structural problem posed by this 'virtual movement', as Riley calls it. Although there could be no 'return', as in the original scenario, because there is no stable starting point, the visual frequency unleashed had nevertheless to be contained. Only before the actual painting can one properly appreciate the master stroke: the horizontal zones of parallel arcs in the areas of compression do not break loose but are firmly held within the tension of the curvilinear field. The change of scale in reproductions usually falsifies this sensation by producing a moiré-effect instead.

The increasing involvement with this immediacy of perception brought about new forms of field organisation which were essential in preparing the ground for the move into colour. In *White Discs 2* (1964) Riley created a powerfully elusive sensation by deleting parts of the regular structure spanning the field. Once the 'white discs' have started to emerge under one's eyes it is not difficult to intimate the complete field of black discs. In a similar way, although with entirely different means, *Breathe* (1966) calls directly on sensation. This phalanx of elongated triangles is clearly built with an off-centre organisation consisting of a short and speedy movement on the left and a long, slow one to the right. But the grand, voluminous pulse, the 'breath' of the painting, is nevertheless puzzling, and it is with a mixture of surprise and delight that one realises that it is through an ingenious distraction of our attention that this sensation is

achieved. The pace of the progressions is dilated by moving in steps of two instead of one by one.

The connection between *Breathe* and the formal organisation of the *Orient* paintings is so obvious that with hindsight one might think that the transition to colour could have been more direct than it actually was. But for Riley using colour was not simply a problem of finding an adequate form, it required a profound revision of her pictorial approach which had so far mainly been based on the principle of contrast and opposition. With the introduction of grey this reckoning had already begun to change, and another clue seems to have been provided by structures in which the physical presence of form and contrast have been considerably eroded. *Static 1* (1966) is all about virtual movement and perceptual energy. The actual structure of minute ovals turning in different directions and at different speeds is barely discernible in this even, highly-charged, field. It was this achievement of having turned the picture plane into a field of pure disembodied energy that, together with the infinite range of delicate shades available in grey, allowed Riley to make the transition from her black and white work to pure colour painting.

The transition to colour

In his monograph on Bridget Riley (1970), Maurice de Sausmarez reproduced a study of 1965 which shows that Riley had tried to apply colour within the structure of her earlier black and white paintings. But she soon realised that a bigger step was required, a kind of denial of previous practices and attitudes, as she later explained in referring to the *Deny* paintings: 'I didn't choose the title *Deny* by chance. The whole group of paintings grew out of, and away from, the absolute opposition of black and white. I wanted something which operated on more levels, was capable of more development, had a more grey'd quality, like the indeterminate nature of reality.'[13]

The complexity of *Deny 2* (1967) can be seen as operating on several different levels of 'denial'. Obviously the structural movement of the ovals works against the regular grid which supports them. The basic theme is the slow spin of a slender upright oval – vertical to horizontal, and back to vertical again. At the edges of the canvas one can see the two different forms of progression: along the top and the bottom the return sequence simply reverts, whereas down the sides

11. Anton Ehrenzweig, 'The Pictorial Space of Bridget Riley', in *Art International*, vol. IX, no. 1, February 1965, pp. 20-24.

12. 'In conversation with Maurice de Sausmarez' (1967), reprinted in *The Eye's Mind*, op. cit., p. 62.

13. 'Into Colour' (1978), reprinted in *The Eye's Mind*, op. cit., p. 90.

one long complete turn-over takes place. The regular half-way position of the horizontal ovals draws one's attention to the internal organisation of the movement. The total field is divided into four equal compartments in which the units are moved around in such a way that the uppermost sequence is reversed in the lowest, and vice versa. But what is more, these four quarter field movements are related to one another in a complementary way. In the top half of the painting the horizontal oval in the middle moves successively down and out towards the edges of the canvas, while in the lower part the movement rises from the vertical ovals in the corners to meet in the centre. This results in a sensation simultaneously centrifugal and centripetal. All formal agents seem to be dispersed and drawn together at the same time.

In sheer formal terms this structure is not unlike that of *Static 1*, but in *Deny 2* Riley has 'denied' the simple black and white contrast by introducing an opposition between a warm reddish grey for the ground and a cool bluish grey for the ovals within a common tonal harmony. Furthermore, the bluish grey of the units is organised in three different tonal gradations which in turn 'deny' the structural developments. If one once more uses the edges of the canvas as a guide one can see that there is a slow progression from light grey to middle grey, a fast one from light to dark grey, and again a slow one from dark to middle grey. They combine to form a diffused dark area at the bottom, clearly reminiscent of the V-shaped dissolution in *Burn*.

As with the complex point movements, however, the description of the operative means falls short of the actual appearance of the painting itself. The sombre elegance of *Deny 2* springs from an unexpected visual opposition between colour and tone. Where the tone of the ground and the ovals are equal the colour contrast between red and blue emerges. In reverse, where the light-dark opposition is at its maximum, the colour differentiation, in a supreme, perceptual form of 'denial', is virtually suppressed. So at one extreme there is an almost metallic glitter, reminiscent of shining leaves turning in the wind, and at the other, our sense of depth and distance is lost in a soft, shadowy mist.

With the *Deny* paintings one has the feeling that, if only one could lift a veil, one would stand in the light of *Chant* and *Late Morning*. But again, there was no such direct continuation. *Deny 2* was an end rather than a beginning, the culmination of a development that includes *Turn* as well as *Shiver*, *Burn* and *Static 1*. The real advance was prepared for by a group of paintings on which Riley worked concurrently. She had in fact introduced warm and cold greys for the first time in 1965 when she began to extend the curve theme of *Crest* and *Current*. By enlarging the body of the curve the visual speed was slowed down and the alternation of warm and cold greys provided a subliminal tension. However, the main aspect of this group of paintings – called *Arrest* – was a complex interlocking between the formal structure and sequences of coloured greys. In *Arrest 2* (1965) a steep diagonal fall of curves on the left corresponds to a larger and shallower rise on the right, both movements being slightly bowed. The progression of warm and cold greys obliterates this off-centre organisation in two ways. Firstly, a fast sequence from dark to light grey transgresses beyond the formal division, and then, most importantly, a second, slower tonal movement starts in the actual centre of the square format with a sharp contrast between the palest grey and the deepest saturated black. *Arrest 2* is a magnificent display of the dynamic stillness that can be effected through the interrelationship of opposing thrusts and weights.

However, as a first step beyond mere tonal modulation the *Arrest* paintings did not lead much further. Rather, in working with coloured greys on a large scale Riley seems to have familiarised herself sufficiently with the still remote problem of colour to realise two things: that intricate formal structures would inhibit the presence of colour, and that the greatest forte of the curve was not the weight it could carry but its long supple edge. The solution did not come at once. But when it was achieved in *Cataract 3* (1967) it looked both inevitable and quite unexpected.

The formal structure of the painting is quite simple – an even diagonal displacement of one and the same curve. The whole stage belongs to what happens to colour, *with* colour and *through* it. Sharing the same curve, two coloured greys – one red, one turquoise – travel in close proximity the full span from a tonally equal, chromatically neutral grey to the full untempered colour contrast. But as soon as they draw nearer to the area of open brilliance something extraordinary takes place, the colour seeming to break loose from its formal vehicle. This may be due partly to the familiar displacement of the area, partly to the high frequency of the curvilinear field and partly to the granular friction which Riley has unobtrusively built into the gradation. The sequence, instead of proceeding smoothly, advances by always moving on, in a kind of 'roll over' rhythm, from one stage before the last (that is to

say 123/ 234/ 345 etc). But whatever the cause may be, the result is visibly there: a cool, fresh, rosy aura envelopes the heart of the contrast, shimmering and sending off sparkles, like dancing reflections, into the greyer areas of the painting. With *Cataract 3* the transformation of the original cyclic scenario, 'repose, disturbance, and repose', was almost complete. Colour could obviously be put into action in an analogous way, as a sensation embracing the tension between an actual hue and its dissolution in coloured light.

There was only one more step to be taken, the relinquishing of the grey envelope. In *Chant 2* (1967) this is accomplished. The colours are reduced to a pair of red and blue, the strongest chromatic contrast, and the forms are simplified into stripes, the most neutral structural vehicle possible. But from these stark means a painting of great presence and authority is extracted. Red and blue in two different combinations, red surrounding blue, blue surrounding red, alternate as they spread across the canvas. The width of the bands increases towards the centre while the white intervals remain constant. Depending on the spectator's distance, the painting offers two different but interrelated experiences. Up close one can see the radiation of colour energy along the edges of the bands: the blue-red-blue combination gives off a dark blue violet shine, whereas the red-blue-red band appears as a lighter red violet and flickers with a luminous yellow orange. As one steps back these elusive details give way to a powerful collective sensation. In the centre, where the broader bands are amassed, an unplumbable depth opens up, radiating an almost colourless light.

Chant 2 was shown at the Venice Biennale in 1968 together with *Late Morning* (1967-68), the other great painting that confirmed Riley's breakthrough to pure colour. A wide horizontal canvas of well over three metres, it is based on a continuum of regular periodic units which carry a cumulative momentum. The pace is set by the brilliant red chord consisting of two red stripes facing one another over a white interval. This steady pulse is accentuated on one side by an adjacent blue stripe which acts as an asymmetrical constant beat. On the other side the only progressive movement, a sequence from blue to green, provides a rhythmic flow in response to this driving thrust. It is organised according to the artist's 'roll over' principle, drawing out a mere ten stages to a span of thirty positions. But this movement is not continuous. The whole passage is subdivided into three phases and rearranged in a dislocated manner. Instead of beginning

with blue or green the first part on the left starts from a central position of turquoise. This appears like a premature echo anticipating the second part which advances from blue to turquoise and continues through into the third part where it culminates in yellow green. With this sequence being mirrored on the right side, the total organisation describes a circular movement encompassing the instantaneous sensation of a volume of pale yellow light emerging in the centre. In a talk at the Tate Gallery in September 1994 Bridget Riley said that she chose the title *Late Morning* because the sensation reminded her of that hour in the Midi just before noon 'when the heat is about to reach its zenith and the air is alive with the dry sound of cicadas.'

Extending the range

The breakthrough to colour resulted in a burst of activities which can roughly be divided into three developments. First of all Riley started to explore the new terrain she had found through *Chant* and *Late Morning* (*Rise 1*, *Byzantium*, *Orient 4*). Then, having discovered certain limitations she made various attempts at strengthening the intensity of colour and giving more body to the fugitive sensations (*Zing 1*, *Cantus Firmus*), and finally, she re-introduced the curve element to give her newly acquired experience with colour a more sympathetic form (*Entice*, *Aurulum*, *Song of Orpheus 5*, *Andante*).

The first group shows the extent to which colour changed her pictorial practice. Formal complexity was sacrificed for the unassertive character of stripes and bands, and for some time *Chant 2* remained the last square format because the extension and opening up of the scope of vision seemed as essential to the release of colour activities as the confinement had been to her explosive black and white images. The big horizontal format entered Riley's repertoire. In retrospect she wrote: 'In the same way that I had to sacrifice distinctive forms in order to release the energy of colour-light, it was necessary to increase the scale of the event in order to prevent focused looking.'[14]

The paintings *Rise 1*, *Byzantium* and *Orient 4*, are each based on a palette of three colours only, without any gradation. After *Late Morning* Riley gave up this kind of colour progression, developing colour's perceptual interaction instead. The relationship of the three chosen colours is therefore crucial. *Rise 1* is made up of orange, violet and green,

Bridget Riley
Orient 4 1970
Acrylic on canvas
The Berardo Collection,
Sintra Museum of Modern
Art, Portugal

Orient 4 operates on the triad of magenta, turquoise and ochre. These are, as David Thompson saw, 'colours which are already biased towards other colours',[15] that is to say composite colours which destabilise each other to form new perceptual identities. However, on close comparison one realises that these colour groups are selected according to a familiar principle because two of them always seem to work more actively together, thus forming a contrast to the third one. The orange and violet in *Rise 1*, for instance, when juxtaposed provide a cool carmine red to which the green then acts as a contrast. Likewise, the blue sensation produced by the green and violet pair is counteracted by the orange. In short, the principle of unequal balance reappears in Riley's colour calculations.

But the paintings are not demonstrations of colour theory. The apparent 'phenomena' of Riley's colour paintings are, in fact, sensations which can only happen under precise conditions, within the specific scale, pitch and frequency established by the plastic structure of the particular painting. So it is indispensable to the upward movement which gave *Rise 1* its name that the horizontal structure of the bands is organised, for the first time since *Horizontal Vibration*, in a purely perceptual way. Only in this context can the most powerful colour accent, the carmine of the orange backed up by the violet, exert its visual pull. *Byzantium* (1969), on the other hand, is not only made up of a different group of colours, red, yellow-green and blue, but the even diagonal organisation of two alternating bands, red enclosing either yellow-green or blue, sets up a tension that creates a completely different sort of colour interaction. The extreme displacement of the vertical axis unleashes a vigorous counter-thrust to redress

14. Op. cit., p. 92.

15. David Thompson,
'Bridget Riley', in
Studio International,
vol. 182, no. 935, July-
August 1971, p. 21.

this imbalance. The whole field reverberates with disembodied energies striking a grand, ceremonial colour chord: purple, gold and white.

The powerful tension of *Byzantium* alerts one to a fundamental paradox in the new colour paintings which explains why Riley increasingly preferred the vertical emphasis for her structures. The perceptual activity of colour seems to be at its most intense when it is seen as a horizontal spread against the vertical forms that carry it. But in order to give some pull to this horizontal diffusion she introduced the steep angle of elongated triangles in a group of paintings all titled *Orient*. The result is a tense 'zone-ing' of the field which in *Orient 4* is further differentiated by a new structural element. It may be remembered from *Shift*, *Pause* or *Deny 2* that, when Riley was involved with progressive movements, cross-over passages played an important part in her plastic vocabulary. In the colour work this concept seems to have been transformed into a literal 'cross over' device, a band of two colour stripes crossed by a third. *Orient 4* shows the enormous potential of this device. The basic pair of turquoise and ochre is crossed by magenta in a regular stroke. Thanks to the tapering points of this magenta stripe, thinning out at the top and bottom of the canvas, the colour relationships within each band are destabilised, giving rise to an astonishing range of colour sensations. The magenta itself travels from a violet inflection at the top to a pinkish orange at the bottom, the turquoise turns towards blue in the middle before settling in a greenish shade, and most dramatically, the ochre shifts from a yellow variant through a warmer rosy tint to a burnt orange appearance. These may be very faint incidents in themselves, but amplified through repetition they gather considerable force. The firmly spanned structure of *Orient 4* opens up into an orange and reddish zone across the top and a blue and greenish one at the bottom.

Extension and amplification were initially important means to accommodate and harvest the profusion of dispersed coloured light. But with time and experience Riley became increasingly concerned with stabilising and substantiating this elusive experience. *Zing 1* shows one direction in which she proceeded. By multiplying and increasing the cross-over device she acquired a new structural element called, in her own studio parlance, 'colour twist', although the literal association of twisting ribbons is misleading. It is in fact a form of movement which allows all three colour stripes in a band to mutually cross one another in turn. In *Zing 1*

there are four diagonal crossings in each band. At the top, green crosses over red and blue, then red crosses blue and green, followed by blue crossing green and red, and finally at the bottom, the sequence returns to its starting position with green again crossing red and blue. This sets off a multitude of minute colour inflections, in effect a virtual colour totality, which in the tight repetitive structure of *Zing 1* is firmly held together in glittering horizontal zones, recalling the compressed intensity of the curves in *Current*.

Although this was only one direction which Riley pursued, *Zing 1* shows very clearly the limits of the attempt to enhance the presence of colour energy as such. Mere intensification would not lend more body and volume to sensations which by their very nature are fugitive and immaterial. So it must have seemed an alternative to tackle the problem from another angle. Between 1970 and 1973 Riley made a whole group of paintings in which she tried to give more weight and density to the play of colour by re-introducing black and grey sequences. *Cantus Firmus* (1972-73) is the most successful of these canvases because, despite its reduced colour presence, it is a masterpiece of pictorial building. The impression of a powerful spatial movement is so strong that it takes some time to realise that almost all the component parts of this painting are identical and constant. *Cantus Firmus* is built on a regular alternation of black, white and grey bands which are surrounded by bands of three colours mirroring one another: olive, magenta and blue facing blue, magenta and olive, etc. Both the periodic repetition of this colour constellation and the width and sequence of the black and grey bands are constant. Only one factor, the grey, moves from a mid-tone pitch at both sides of the painting in two different progressions – slow on the left and quicker on the right – towards a dark grey, virtually indistinguishable from the black bands close to it. This off-centre organisation is buried in a manner comparable to *Black to White Discs*. But the sensation is completely different. However reduced the colour activity may be, the fusion with the greys destroys the notion of a regular metre as well as the perception of any continuity in tone. The width of the bands and their planes in space seem to glide and fluctuate, disclosing a dense and yet curiously permeable space.

Re-introducing and transforming earlier themes and devices is obviously one of the ways in which Riley proceeds. Sometimes this produces an odd unruly painting but it can also open up unexpected territory. At first glance *Entice 2*

(1974) seems simply to combine the curve element with greys, rather in the manner of *Cantus Firmus*. A vertical curve is diagonally displaced so that a continuous field of narrowing and widening forms emerges, every third interval carrying a constant grey of the same tonal pitch as the colours which flank it. There also seems to be a repetition of the blues, greens and reds which mirror each other across the white intervals. But this order is deceptive because the continuity is undermined by rhythmic syncopations attracting and evading our attention. Identical colour pairs are interspersed with contrasting pairings, and the apparent overall organisation harbours a number of hidden accents and shifts, the most notable of which is the emphasis towards warm greens and reds on the right side.

In spite of the power and novelty of this image, Riley did not carry it further. As with the earlier choice of stripes she never goes for 'imagery' as such, but rather for pictorial function and the sensation conveyed. In this way a structural observation in *Entice 2* seems to have indicated a change of direction. The narrowing of the curves in the pinched parts virtually severs the curvilinear field, and these acute passages seem to have suggested a new role for colour twists used in paintings such as *Zing 1*. In turning three colours around a curvilinear axis Riley saw the possibility of accumulating groups of disembodied colour across the surface, quite independently of the previous confinement to horizontal zones. This became the dominant approach in her work for the next few years.

Aurulum (1977) is already a highly developed painting. One clue to the building up of complexity in Riley's work is her ability to take small and steady steps. First, she let the colours down with grey to facilitate their interactions; then, lightening and clearing them again, she explored the two different structural possibilities inherent in turning colours around a curve: tight twists and open expanding loops. And eventually, with paintings like *Aurulum*, the white intervals gave way to pale tinted greys which act as a conduit for the spread of colours.

The whole field of *Aurulum* is organised in two ways, firstly, by changing the number of curves carrying the same sequence of colours, and secondly, by reversing this sequence within the continuous formal structure. Each colour movement involves seven cross-over stages. At the top left corner, for instance, it begins with blue, rose and yellow-ochre crossing in turn, continues with a full repeat of this sequence and

32

finishes with blue again at the bottom. Varying the number of curves carrying the same progressions and steadily shifting their positions along the diagonal drop of the field creates vivid clusters and chords of luminous colour. These golden, pink and yellow sprays are supported by a hidden inversion of the initial colour sequence to yellow-ochre, rose and blue. Through this a slight inflection is added to the loose glissandi, lending a kind of iridescent bloom to the painting.

It seems almost impossible to go beyond such subtleties. But having trained her vision in this high-keyed colour fluctuation Riley went one decisive step further. In the *Song of Orpheus* paintings she split up the grey intervals which so far had served as receptacles for the colour activity into two more hues. This meant that the whole balance of colours 'already biased towards other colours' had to be readjusted to a shifting constellation of five colours: violet, blue, green, yellow and pink. In *Song of Orpheus 5* (1978) this palette is separated into two different colour twists. A theme of three colours, pink, blue and green, is interlaced with another consisting of two, yellow and violet. Their intricate structural relationships truly defy penetration. But far from being confused the resulting sensation is a clear contrast between rippling green and yellow clusters and hazy rose passages working against one another.

By the time Riley painted the *Song of Orpheus* paintings she had achieved her primary objective, to find a footing in colour, though with an unexpected consequence. In 1992 she said in conversation with Michael Craig-Martin:

> I saw that the basis of colour is its instability. Instead of searching for a firm *foundation, I realised that I had one* in the very opposite. *That was solid ground again, so to speak, and by accepting this paradox I could begin to work with the fleeting, the elusive, with those things which disappear when you actually apply your attention hard and fast.* [16]

So successful was this achievement that, if one views the *Song of Orpheus* paintings with an open unfocused gaze they come precariously close to dissolving into coloured light. But this of course provoked Riley's building temperament. However subtle and refined her paintings may become from time to time, the cultivation of sensitivity is not her aim.

In the curve paintings after 1978 this tendency towards evanescence is counteracted by deepening colour and modifying the overall organisation. One of the very last curve paintings, *Andante* (1980-81), shows how far this could be carried. Green, turquoise, violet, magenta and dull orange-ochre are the constituent colours which are organised in a new plastic way. Instead of regular or periodically recurring rhythmic patterns, broader structural considerations are brought into play. Vivid accents of green, in conjunction with turquoise and violet, flash across a bed of warm colours which draws upon interactions between magenta, dull orange-ochre and, once again, violet. This free disposition of the curving colour twists includes a shift in the colour emphasis. Whereas in the larger part of the painting reddish interactions prevail, the balance is reversed in the lower right side in favour of a cool blue-green giving weight to the sharp breaks and interjections of these colours elsewhere.

In 1981, when Bridget Riley completed *Andante*, she had already begun to extend and transform this free perceptual organisation. The broad simple colour band reappeared, carrying a palette of unprecedented strong and bright hues. After ten years of intense involvement with chromatic interaction Riley had shifted the basis of her work once again; and this not for the last time in the past two decades. Such changes are neither capricious nor deliberately engineered in pursuit of novelty. She herself scorns any value attached to change as such, because to her sensibility movement is an essential condition of preserving the vitality of life. In this sense the rich and continuous development of her work, now spanning more than forty years, is a rare and precious achievement in itself.

16. *Dialogues on Art,* op. cit., p. 56.

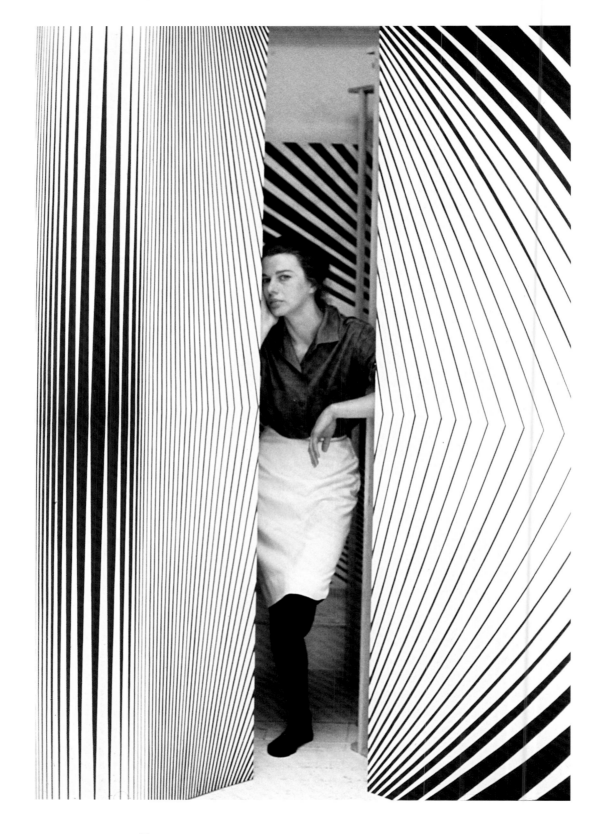

Bridget Riley with
Continuum 1964
Photograph by Snowdon
Courtesy Camera Press Ltd

34

CONTINUUM
BRIDGET RILEY'S 60s AND 70s
A VIEW FROM THE 90s

Lisa G. Corrin

'Just what has turned London into one of the world's three capitals of art? Who did it, and how? And what kind of people are they?' Thus begins *Private View*, a collaboration between Bryan Robertson, John Russell and Lord Snowdon published in 1965, remarkable for its documentation of the first wave of what is now popularly referred to as 'Cool Britannia'.[1] The repositioning of London as a vibrant force on the international stage was a phenomenon that entered broader public consciousness long before *Sensation* (the exhibition of the Saatchi Collection of young British artists at the Royal Academy in 1997) attracted exceptional attendance. By 1965, the London art world had already launched itself on the international stage and had identified the leading players who would support and sustain a new self-image as a powerful voice within the New York - London - Paris cultural axis.[2]

Chapter 4 of *Private View* presents artists who had begun making their reputation within two years of the publication. One does not go far in this chapter before coming to a sudden halt at an arresting photograph of Bridget Riley posing between the dismantled sections of *Continuum* (1963), an experimental, three-dimensional structure in black and white, a sort of Riley-in-the-round.[3] Riley stabilises herself on one leg and leans against the converging striped surfaces. Her gaze, like her pose, both reveals and conceals. It is at once wary and challenging. Riley appears to invite us (or, perhaps, dare us) to come into her hypnotically-charged lair whilst at the same time barring entry. This extraordinary and paradoxical image of the artist balancing with perfect poise amidst her imposing work seems at once precarious and fearless. For me, these two words aptly describe Bridget Riley's paintings and her approach to art-making. Although it remains an anomaly in her oeuvre, *Continuum*, a particularly early foray into the not yet fully explored area of environmental installation, was typical of this independent artist, who endeavoured to push her ideas as far as they could go. It

was a one-off experiment, like her few 'shaped' paintings such as *Climax* (1963), which she was not to repeat. A willingness to take risks, to follow her strong instincts, has characterised Riley's career from her first move into black and white with the landmark *Kiss* (1961). Her *modus operandi* has always been a balancing act. That is the task she has set herself.

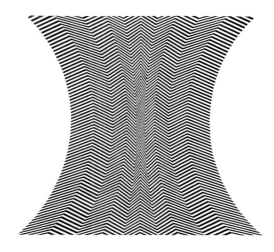

Bridget Riley
Climax 1963
Emulsion on panel
Private collection

'The basis of my painting is this: that in each of them a particular situation is stated. Certain elements within that situation remain constant. Others precipitate the destruction of themselves by themselves. Recurrently, as a result of the cyclic movement of repose, disturbance and repose the original situation is re-stated.'[4] The impact of this aesthetic position on the viewer is profound, and like the expression on Riley's face in the Snowdon photograph, challenges us to find our own way through her perceptual labyrinths.

The most persistent memory of my first visit to Bridget Riley's studio is the impact of two paintings – *Static 2* (1966), an all-over white painting with dark ovals dispersed in an oscillating grid, and the coloured grey curves of *Cataract 2*

1. Bryan Robertson, John Russell, Lord Snowdon, *Private View*, London: Thomas Nelson & Sons, 1965, p. 3.

2. See David Mellor, *The Sixties Art Scene in London*, London: Phaidon, 1993.

3. *Private View*, op. cit., pp. 206-07. This no longer extant installation, exhibited in Gallery One, was not commented upon by the critics and is known only through this photograph and a small maquette retained by the artist.

4. Riley quoted in 'Perception is the Medium', *Art News*, vol. 64, no. 6, October 1965, pp. 32-33, cont. p. 66. Reprinted in *The Eye's Mind: Bridget Riley: Collected Writings 1965-1999*, ed. R. Kudielka, London: Thames & Hudson, 1999, p. 62.

(1967). It has become something of a cliché, and not a particularly useful one, to merely describe the vertigo-inducing effect of her works of the sixties and seventies such as these. Critics of the time accused them (in some cases it was a backhanded compliment) of making them feel ill and 'tripped out', causing 'migraine', 'mounting panic', 'anxiety', 'dizziness', 'seasickness', 'nausea'. Yet, however visceral the impact of these works was upon me, they engendered a lingering fascination not with their effect on my eyes, or my body, for that matter, but as to what kind of eye they required to make them. I thought then, as I have continued to do, that such paintings require 'a responsive eye' and a formidable and intense capacity for looking and reconnecting to a perception, a memory, an experience.[5] For looking is a complex act of translation especially if one is making paintings with 'visual prickle', that is to say, if one aspires to leaving an impression more indelible than the observed phenomenon itself. Therein, for me at least, rests a key ingredient of Riley's brilliance. I can think of few such searing eyes in the history of recent art that can surpass the exactness of hers as she wrestles with 'situations' (as she refers to the 'problems' she sets herself) in the medium of painting, as she puts the structures of the medium through their paces.

Riley's eye is, however, not a purely retinal organ. She manipulates the formal language of art-making – form, colour, shape – to articulate 'the *basis of vision* rather than its appearance.'[6] Indeed, what has continued to set her apart from many abstract painters of her generation has been her insistence that all of her work begins with the manipulation of that language until, instinctively, she recognises an echo of a sensation which is, however, unattached to a particular experience. Her eye remains simultaneously attached and detached in order to 'see' the echo, and then to draw it to the surface in a way that will create a work capable of negating the fixity of a viewer's assumptions about reality. As Frances Spalding so eloquently argues in her essay for this catalogue, this 'poetics of instability' is amplified by Riley's choice of titles – *Deny*, *Ambivalence*, *Suspension*, *Drift*, to cite but a few examples.*

Riley's 'aesthetic of instability' is crucial to understanding her contribution to the discourse of abstraction. It is not only manifest in the effect created by her paintings on the viewer. More than oscillating, her paintings vacillate, putting into question any claim to objectivity by undermining in the most concrete terms the viewer's conviction in the certainty of his

or her perceptions. Then, there is Riley's working process, unusual at that time, which included an early decision to turn the actual production of her works over to assistants. This may also be read as an attempt to destabilise conventions regarding originality and authorship, concerns that were to preoccupy both conceptual artists and, in the late eighties, artists engaged in appropriation. An artist who comes to mind readily is, of course, the American painter Philip Taaffe.

Taaffe helped himself to generous servings of Riley's oeuvre in the creation of his own works such as *Expire* (a correlative to Riley's *Breathe*) and *Shaded Sphere*, (a correlative to Riley's *Tremor*), as well as 'wave' pictures derived from Riley's *Fall*, *Crest* and *Cataract 3*. His retrieval of Riley's aesthetic tendencies of the sixties and seventies through an act of strict interpretation was, in his words, a 'liturgical re-enactment' of abstract painting as one of the sacred rituals of modernism. In performing this ceremony, he tested the

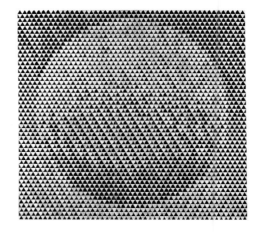

Philip Taaffe
Shaded Sphere 1985
Silkscreen, enamel, collage
and acrylic on paper
Gagosian Gallery, New York

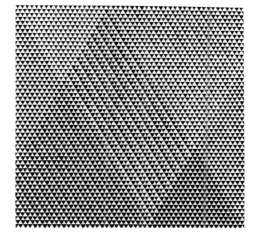

Bridget Riley
Tremor 1962
Emulsion on hardboard
Private collection

5. *The Responsive Eye* was the title of the exhibition about perceptual art, organised by the Museum of Modern Art in New York in 1965, which launched Riley's international career.

6. The artist quoted in 'The Art World' in Jonathan Aitken, *The Young Meteors*, London: Secker & Warburg, 1967, p. 196. The italicized emphasis is my own.

*Only *Deny* is included in the Serpentine Gallery exhibition.

longevity and validity of its utopianism and claims to purity, using appropriation to commit sacrilege against its most revered tenets.[7]

In light of critiques of modernism by artists such as Taaffe, whose contributions have revealed the ideological substructures of its precepts, it is unavoidable for one weaned on postmodernism, such as myself, to read into Riley's production process – her delegation of the actual fabrication of her paintings – a radical strategy. However, Riley has always made clear that she has viewed herself as a member of a trans-historical community of artists taking up 'situations' that have engaged painters across the centuries. Although it is not 'gestural', and does not privilege the individual artistic mark or brushstroke, Riley's work, as Jack Burnham has pointed out, retains a conviction in the expressive potential of an artist's personal 'handwriting'.[8] While she made her own meticulous, hand-drawn and hand-cut templates for her curves, Taaffe made precise linoleum-block carvings, derived from his analysis of Riley's wave structures, using an opaque overhead projector with mathematical models of sine waves. The prints of the carvings were made in sections which were then pieced together. Taaffe's surgical and ironic strategy is in stark contrast to Riley's position regarding the artistic 'hand', or 'indexicality'. Yet, while the fabrication of her art is distanced from any originating gesture she, paradoxically, never subscribed to Minimalism's impersonal 'styleless style'.[9]

It may seem as though Taaffe's aesthetic sensibility, and that of Riley, are divided by an intraversable chasm. However, Taaffe's borrowing of Riley's art is an effort to penetrate her sensibility. While his works after Riley resemble hers only superficially, they often draw attention to some of the most distinctive characteristics of her art by cancelling out their effects. In so doing, he offers some compelling observations about her work and its opposing relationship to strict formalism à la Greenberg. For example, Taaffe has referred to the 'strange topography and strange surfaces' of his own paintings, which he compares to Riley's flat and and restrained surfaces.[10] In Shaded Sphere, he paints the secondary colours produced by the eye when it sees black and white. His dense white areas are vibrant with colour and evident brushwork. In other works, the thick surfaces are built up by using successive layers as well as by combining materials such as paint or paper, or media such as printmaking and painting.

The expressiveness inherent in such works as Shaded Sphere is also connected to Taaffe's interest in what he has described as the 'micro-geographical locations in Riley's work . . . getting inside the painted spaces to open them up as passages to a world of poetic and evocative sensations.' It serves as a reminder of Riley's position, with regard to her own contemporaries, in particular her violation of the code of blankness and temperamental coolness. From the outset, Riley has stated that she was never interested merely in creating optical illusions for their own sake. Her paintings were born from the world of experience and continued to live through the experience of the viewer. Despite their plastic considerations, their economy of form and colour, they could not be torn from the world of perception. Taaffe's Riley is exalted exactly for the expressiveness most proscribed by modernism. In intensifying our awareness of this aspect of her work, he also provides an important reminder of Riley's relationship to the history of modern art. For, the early foundations of her eye were developed not through a scientific study of colour and geometry or modernist theory, but through observation combined with intimate experience of Impressionism and Post-Impressionism (she made early divisionist studies), and, later, the exuberant work of Jackson Pollock.

What was the impetus behind Riley's then unconventional working method? From Robert Kudielka, who has watched this process develop over several decades, we learn of Riley's gift for organising her energies.[11] Her delegation of painting to assistants served different functions at different times depending on pragmatic needs. Her early works developed out of drawing, the ideas first worked out on paper until the desired results were achieved in full-scale studies. Riley concentrated her attention on the 'situations' generated within the painting while her assistants executed the final work. The later colour works that grew in scale required full-sized cartoons, even for details. It sometimes takes the artist days to remix and match colours from her studies, an exhausting process relieved by the intervention of other hands.

I would like to speculate further on Riley's working process by returning to her searing and astute eye. Acutely aware of memory and sensation as shifting and uncertain structures, perhaps we may consider Riley's yielding to assistants as a way in which to preserve the conviction of that extraordinary vision. By remaining one step removed from the final stage of the creative process, she found a way of

7. This phrase was used by Taaffe in a conversation with the author on 14 April 1999. The painter Ross Bleckner created works in dialogue with paintings by Riley, created after 1980, and thereby outside the purview of this exhibition. Riley met with both Bleckner and Taaffe in 1986.

8. Jack Burnham, 'The Art of Bridget Riley', *Triquarterly*, no. 5, Evanston, Illinois: Northwestern University, 1966, p. 62.

9. Loc. cit.

10. A statement made in conversation with the author on 14 April 1999.

11. The following account of Riley's working method is based on a conversation with Robert Kudielka on 14 April 1999.

retaining her self-reflexive edge, to adjust, hone, refine and re-focus her vision as necessary. Was this, perhaps, also a means by which to engage and control a 'situation' as closely as possible, to push her ideas as far towards resolution as they could go and then to be able to release them into a fluid space affording an open reading. Was this a means by which to guarantee the rigour of each work even though each painting grew out of its own dialectic?[12]

The need to push abstraction to its limits, to put it through its paces, was endemic to modernist rhetoric of the medium in the sixties and seventies, dominated as it was by the burgeoning fields of art theory and aesthetic criticism in which artists participated actively. In a highly competitive, increasingly professionalised, commercialised and internationalised art world, each painter had to find a distinguishing space for him or herself and develop a visual language in order to create a position within that world. With exhibitions of Abstract art dominated by the monochrome, the stripe, the grid, an artist's exploration of variations in mark-making, might easily be passed over except by one's peers inside the debate, where it might be understood as pivotal to one's practice. Difference was measured by the toughness and rigour brought by an artist to an idea. Relationships and reputations rose and fell over where one stood on matters concerning how and whether the integrity of the medium of painting or sculpture was preserved or violated. A time of histrionics and heroics, studio activity was a very serious arena indeed. While the discourse of art progressed in fractions of increments, each artist had to exploit his or her distinct territory and be prepared to invest everything to protect these interests. In this antagonistic environment, Riley toughed it out with the best of them by ensuring that her work would be tough and relentless in its insistent intelligence and its insistent presence.

Riley's renown skyrocketed following her much-acclaimed participation in the exhibition *The Responsive Eye,* organised by the Museum of Modern Art, New York, in 1965. The exhibition positioned her as part of a somewhat incongruous mix of international artists including Josef Albers, Richard Anuszkiewicz, Robert Irwin, Ellsworth Kelly, Morris Louis, Agnes Martin, Kenneth Noland, Larry Poons, Peter Sedgely, Frank Stella and Victor Vasarely. All of the participating artists, according to the curator William C. Seitz, were making objects which could be categorised as perceptual art, a term fabricated to bring under one rubric a range of different practices

that, in retrospect, seem to stretch the category in which he had placed them to bursting point. With MoMA's imprimatur, perceptual art became Op and was readily picked up by the media and the marketplace, and even by cartoonists such as Erich Sokol.[13] A modern art movement with just a whiff of the shocking about it was born. The cover of the catalogue and private view card for *The Responsive Eye* featured Riley's painting *Current,* identifying her as a leading light in the field. Interviews with her as the most articulate exemplar of the 'movement' appeared everywhere from serious art journals to *Women's Wear Daily.* Her opinions were sought on subjects ranging from contemporary art, Britain's Mods and Rockers, to her style of entertaining and her taste in fashion.[14]

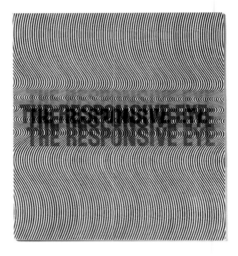

The Responsive Eye
Catalogue cover, 1965
The Museum of Modern Art, New York

Riley garnered notable support in the United States in reviews of *The Responsive Eye* and other exhibitions and also from significant artists such as Josef Albers, Ad Reinhardt and Barnett Newman, and distinguished art historians such as Irving Sandler. Yet, although her rise to art-world stardom was meteoric, Riley's integration into the modernist canon remains incomplete. At the time, this was due, in part, to the ascendancy of Minimalism and the ideas of the American art critic, Clement Greenberg. The dominant views of Greenberg and his acolytes in the United States and abroad did not accommodate the unique – he might say idiosyncratic – aspects of Riley's approach to abstraction. I use the phrase 'might say' because Greenberg never turned his pen to Riley's work and through this omission he effectively excommunicated her from his fold. The consensus of her generation was that it was better to receive Greenberg's

12. This idea arose out of a discussion with Julia Peyton-Jones, co-curator of this exhibition.

13. Op art is a term applied to two-or three-dimensional abstract works of art using illusion to generate perceptual responses in the viewer. The term was first used by Jon Borgzinner in his article, 'Op Art: Pictures that Attack the Eye', *Time,* New York, 23 October 1964, pp. 42f.

14. See, for example, the interview between the artist and Ann Ryan in *Women's Wear Daily,* 11 May 1965, pp. 4-5. This publication is the fashion retailer's daily newspaper.

Tatler
17 June 1964
Courtesy The Illustrated
London News Picture
Library

Vogue Australia
'What's in Vogue: OP'
October 1965
Courtesy Condé Nast
Publications, Australia

Richard Shops
window display
London, 1966

admonition than not to receive any notice at all. At least if he was critical, it meant an artist's efforts were carefully considered. What aspect of Riley's painting would have provoked – or not provoked – his response?

Robert Kudielka has discussed here and and elsewhere, the specific areas in which Riley fell afield of Greenberg's dicta, as has Frances Spalding in her essay.[15] However, I believe that the biggest barrier to the appreciation of Riley's work lay outside her paintings and, also, outside her control. Concurrent with the critical reception of Riley's art was its appropriation within the sphere of mass culture. The sixties did not just see a burgeoning of serious art theory; they were witness to the coming-of-age of the art market and the increasing commodification not only of works of art, but also of the artist.

Riley's high impact works took on a graphic appearance in reproduction that had no relationship to the physical experience of their complexity. Their effects were, and remain, resistant to reproduction even with today's most sophisticated options. As Anton Ehrenzweig described them, 'Her picture plane threatens to split apart almost at any point. The areas of stability tend to isolate themselves just because of their singular static quality; it needs a powerful pulse to draw them into life.'[16] That powerful pulse was all but lost in the copy, draining them of their potency. Yet, her paintings could be transformed with ease and speed into patterns by textile manufacturers who saw her work as 'simply exercises in spots, stripes and eye-dazzle'.[17]

Dress manufacturer and collector Larry Aldrich set the ball rolling when he bought one of Riley's paintings and transferred a reproduction of it onto yards of fabric. When,

shortly before the opening of *The Responsive Eye*, he invited an unsuspecting Riley to his office to see the results, he thought she would be flattered. She was deeply distraught, but the dresses went on the market.[18] Riley did not object on monetary grounds – she was offered, but refused, compensation. She felt that Aldrich's action had violated both the integrity of her art and that of textile design as a craft in its own right. 'If manufacturers and designers appreciated the principles on which my images are based,' she argued, 'and re-applied them to dresses, they'd get something different and perhaps quite marvellous. But they just lift them wholesale, and on the most superficial level. So nothing has unity. I've yet to see an Op fabric which is wearable. I think they're ugly beyond belief . . . I feel like I've been invaded.'[19]

Riley did not need New York to launch her as the icon of the Swinging Sixties. A *Tatler* cover of 17 June 1964, for example, titled 'The Shape of the 60's', superimposed Riley's profile on what looked like one of her black and white paintings. But, with the intervention of manufacturers, designs derived from Riley's complex works became immediately recognisable emblems of the time internationally as Op metamorphosed into pop. Op earrings, dresses, suits and knickers were 'exhibited' in the windows of leading department stores such as Lord and Taylor in New York, and shops such as Dolcis Shoes and the clothiers Richard Shops, in London. Look-alike Op art backdrops appeared as sets on popular television programmes including ABC TV's *Blackpool Night Out* and *Thank Your Lucky Stars*. Joyce Egginton, writing in the *Observer*, was amused to find visitors to *The Responsive Eye* had become living Op art. Op had arrived as a style as early as the private view where, as

15. See *The Eye's Mind*, op. cit.

16. Anton Ehrenzweig, 'The Pictorial Space of Bridget Riley', *Art International*, vol.9, no.1, 1965, p.24.

17. Prudence Fay, 'Quick Cue: Op-position', *Queen*, London, 5 January 1966, p.9.

18. Riley quickly discovered that there were no copyright laws in the U.S. to protect the rights of artists with regard to the reproduction of their images. She found herself in the position of having to wage years of legal battles to protect her work from commercial plagiarism. Artists, such as Riley, started their own initiative to achieve the first U.S. copyright legislation in 1967.

19. Prudence Fay, loc. cit.

Eggington observed,

> . . . a girl in a floor-length dress of wide black and white stripes stood contemplating a picture of concentric circles. Another woman with a stole like a draughtboard was engrossed in an enormous canvas of wavy lines which troubled the eye as much as the garment she was wearing.[20]

The October 1965 issue of *Vogue Australia*, devoted to Op, described Riley as its 'British Wizard'. A photograph of her at a work table appeared along with a virtual lexicon, running throughout the magazine, of the style's manifestations: 'piebald beach boots, peep-toed, two-faced darlings especially designed for *Vogue* and made in black and white gros-grain', stockings with 'Dalmatian spots', make-up and nail varnishes 'used in various far-out ways, such as black dots on chalk white'[21] Paradoxically, Op-style, by now ubiquitous, became synonymous with avant-gardism, the embodiment of free-expression as the following tag line in *Vogue* illustrates: 'OPinionated people who are anxious to project a sharp, not-to-be-ignored, individual self-image, will OPt for slick little shifts to make themselves in Sekers OPtical-illusion silks. OPposite, A-line shift from Vogue Pattern 6180 in a moiré-effect print'[22] Indeed, by 1966, Op had been fully mainstreamed. In 'A plain guide to Op', Joyce Hopkirk provided readers of the London *Woman's Journal* with an abbreviated history of 'How Op Art has influenced fashion', listing everything from cuff-links and mugs, to the Op Art dining room of dress designer Mary Quant, and Peter Evans' first Op Art eating house. 'You can buy examples of Op Art for a few shillings, on cuff-links, for example, or you can pay up to £1,000 for a Vasarely or Riley.'[23] Why spend a fortune on the real thing when you could have a functional surrogate?

'Few painters have been so ruthlessly plagiarised by commerce' the critic Robert Hughes has observed of the 'packaging' of Bridget Riley's art:

> As soon as her tightly organized, black-and-white abstractions began to wrench and prick the eyes of an international public in the mid-60s, a horde of fabric designers and window dressers moved in . . . and Op itself became, in the hands of its exploiters, a chic gimmick that could market anything from underwear to wallpaper. By the summer of 1965, it seemed that every boutique in the West had its own coarse versions of Bridget Riley's optical dazzle.[24]

As Riley herself wrote, in Autumn 1965, the exploitation skewed public understanding and critical response:

> The Responsive Eye was a serious exhibition, but its qualities were obscured by an explosion of commercialism, bandwagoning and hysterical sensationalism. Understandably, this alienated a section of the art world. Most people were so busy taking sides, and arguing about what had or had not happened, that they could no longer see what was actually on the wall. Virtually nobody in the whole of New York was capable of the state of receptive participation which is essential to the experience of looking at pictures. Misunderstandings and mistaken assumptions took the place of considered, informed judgement.[25]

The large-scale commodification of Op and, specifically, Bridget Riley, set a precedent, ushering in a new market-driven era in the fabrication of artistic 'movements'. New communications and mass-marketing strategies transformed art with popular appeal into 'pre-digested art' accessible to a mass audience through dissemination in magazines, television and on the high street, in addition to the usual postcards and posters of masterpieces-in-miniature.

For Greenberg and his followers, the worst accusation that could adhere to an artist's reputation was that his or her work was not art but kitsch. In his essay 'Avant-Garde and Kitsch', Greenberg identified kitsch as derivative forms and mechanically produced products fit for popular and mass consumption and created by the marketplace as diversions for those 'insensible to the values of genuine culture'.[26] These ersatz forms included 'popular, commercial art and literature with their chromeotypes, magazine covers, illustrations, ads, slick and pulp fiction, comics, Tin Pan Alley music, tap dancing, Hollywood movies, etc., etc.'[27] In this world structured by the hierarchy of high Art and low kitsch, even a vigilant artist was continually under pressure to succumb, to make something that might seem, at first to be art, but that was only faking its effects by borrowing its, 'devices, tricks, stratagems, rules of thumb, themes'[28] To succumb was to be condemned to the epithets 'bad taste', 'trivial' and 'decorative'. To be 'decorative', according to Greenberg, was to participate in a category of marginal culture associated with pattern and design and including dressmaking, handicrafts and china painting, in short, the category of the feminine. If a painting could so easily become a fashionable dress, it joined the realm of frivolous (women's) activities, as

20. Joyce Egginton, 'Fashion follows Op Art', *Observer*, 28 February 1965.

21. See *Vogue Australia*, October 1965. The quotations are taken from p. 51 and p. 59 respectively. The photo of Riley appears on p. 59.

22. Ibid., p. 57.

23. Joyce Hopkirk, 'A plain guide to Op', *Woman's Journal*, London, February 1966, p. 26

24. Robert Hughes, 'Perilous Equilibrium', *Time Magazine*, 16 November, 1970, p. 42.

25. Bridget Riley, 'Perception is the Medium', *Art News*, vol. 64, no. 6, October 1965, p.66. For further, more recent comments by Riley on the subject of her 'packaging' see 'A Reputation Reviewed', an interview with Andrew Graham-Dixon in *Bridget Riley : Dialogues on Art*, London : Zwemmer, 1995, pp. 64-74.

26. Clement Greenberg, 'Avant-Garde and Kitsch', in *Art and Culture : Critical Essays*, Boston : Beacon Press, 1989, p. 10.

27. Ibid., p. 9.

28. Ibid., p. 10.

opposed to the earnest intellectual world (of the masculine). How, then, could it make a significant contribution to the discourse of non-objective art?

Crude gender stereotyping pervades early discussions of Riley's work with critics divided between those who would describe her work in terms typically associated with masculine bullying terms, such as 'aggressive', 'confrontational', and 'assault', and those who found in it a feminine touch, describing it as 'dainty', 'tender', 'vulnerable', 'delicate', and 'giddy'. It seemed difficult for writers to reconcile their characterisation of 'hard' abstract painting, principally the domain of the male-dominated art world, with the appearance of Riley's art and the appearance of Riley herself. Here was a stunning woman who, far from being a shrinking violet, was one of the leaders of the pack, and made equally stunning art as rugged, courageous, assertive and self-possessed as that of any of her male counterparts. Consider this excerpt from the commentary on the artist by John Russell, that followed on from the Snowdon photograph, in *Private View*, of a sultry Riley emerging from the crevice of *Continuum*:

> Set to imagine the woman who could conceive and carry out these paintings, we might well picture to ourselves a barrel-bodied paragon of determination, a tenacious and fifty-ish she-gorilla given to judo and the solution in secret of championship-level chess problems. Tenacious Miss Riley is, beyond a doubt Physically she looks as if one could pick her up with the nearest pair of tongs.[29]

For Russell, the waifish Miss Riley poses a contradiction to the manifestly apparent intellectual acumen so clearly visible in her painting. Robert Melville offered a no less clichéd image of femininity when he depicted her as a cross between the demure lady and the dangerous seductress. 'She assumed the modest patience of a sewing woman but it was the disguise of a *femme fatale*. Her work released a disruptive force . . .'[30] It is not only Riley's work which is disruptive and vexing, it is also how she has constructed her identity as an artist who is also a woman.

Riley must have found herself battling on three fronts. She had to fight for her aesthetic position. She had to fight against the commercialisation of her art. She also had to fight against gender stereotyping in a male dominated art world. In her landmark essay on the artist Lee Krasner, Anne M. Wagner has considered how a woman artist's

> . . . *subjectivity, that sense-of-oneself-as-an-artist (a sense inseparable from an idea of one's art) is formed What kind of uneasy peace is made between gender identity and artistic identity? . . . Rewriting history around issues of gender is not about reversing the 'facts', whatever they may be, it is about taking both public and private representations and estimations of women's place in art as among the determinants both of the artist's self and of her art.*[31]

Any revision of Riley's reception and eventual positioning within the history of art of the sixties and seventies must consider these conditions. Riley's art with its unrelenting visual toughness both for the maker and for the viewer, seems to me a strategic tactic in her construction of a public and private self that would violate the representation of her as a decorous object making decorative art.

Although Pop art made important inroads in blurring the boundaries between categories of art and pop culture, these categories were still relatively immovable in the sixties. Once feminist theory had entered art history and art practice in the late sixties and began challenging the values embedded in such hierarchies as high and low, and art and craft, the way was opened for artists to work with materials and processes of their choice, without feeling constrained by prejudices such as Greenberg's. In the seventies, the Pattern and Decoration Movement, led by artists such as Miriam Schapiro and Robert Kushner, used patterned surfaces 'to mount a multi-coloured, multi-media, frontline attack on the purity of formalism'.[32] Today, these collapsed boundaries are taken for granted by artists and words like 'decorative' or 'kitsch' are no longer pejorative. To describe Philip Taaffe as 'decorative' or Jeff Koons as 'kitsch' is to provide context for the cultural references embedded in their work, not a qualitative judgement. [33]

In terms of the commodification of an artist or his or her style, many artists, including Jeff Koons, have made this the subject of their work and with savvy and sophistication have appropriated and manipulated the strategies of the marketplace. Damien Hirst has capitalised on this tendency with particular brilliance. His restaurants Quo Vadis and Pharmacy, as well as his brief appearance in the pop music charts are just two examples of how he has seamlessly merged the walls of his studio with those of the marketplace and popular culture, making the artist's engagement with these activities indistinguishable from one another. Hirst has leveraged his

29. *Private View*, op. cit., p. 209.

30. Robert Melville, 'The Riley Dazzle', in *Architectural Review*, October 1971, p. 226.

31. Anne M. Wagner, 'Lee Krasner as L.K.', reprinted in Norma Broude and Mary Garrard, eds., *The Expanding Discourse: Feminism and Art History*, New York: Icon Editions, 1992, pp. 428-29.

Damien Hirst
Argininosuccinic Acid
1995
Gloss household paint
on canvas
The Saatchi Gallery,
London

Peter Davies
*Black and White
Spirals Painting*
1998
Acrylic on canvas
Collection Simmons
and Simmons

status as an art-world icon to raise compelling questions regarding the collusion between art and commerce, and in so doing, has challenged the limits of artistic activity and the definition of the artist. When Hirst, the artist most synonymous with the second wave of 'Cool Britannia', encoded Riley's work in the patterns of his dot paintings such as *Argininosuccinic Acid* (1995), he was not merely appropriating her works from the sixties. His gesture invites comparison between Riley's iconic status within the history of modern British art and his own. Hirst's dot paintings have been appropriated by British Airways in their logo for Go, the hip, economy airline that flies to the Continent. Exactly the aspects of Riley's work that inhibited a full appreciation of her achievements have become a source of Hirst's inspiration and the proliferation of his reputation, making him one of the most famous, and the most infamous, artistic figures of the nineties. 'Kitsch? Decoration? Commerce? What's new? What's the fuss?', the voice of the nineties seems to ask. Hirst has outwitted the market by appropriating its behaviour and beating it at its own game.

The current generation has cleared the field so that they, and we, can look at Riley's work with fresh eyes and a new sensibility. Peter Davies places Riley eighth on his list of greatest artists in *The Hot One Hundred* (1997) and in *Text Painting* (1996) he pays homage to her, 'Bridget Riley, so complicated but such eloquent funky results'. *Post-Hypnotic*, an exhibition at the University Galleries of Illinois State University (1999), looked at painting since the mid-eighties which, under the influence of Op, 'put the human retina on trial, reminding us that what we see depends on how we see, and that other realms of vision can open out from the unstable act of seeing.'[34] The artists included in the exhibition create images that seem to 'transgress the frame and move right

into the viewer's space' and demonstrate how far Riley's premise has been pushed with the advent of Virtual Reality and other technologies.[35] In Diana Thater's recent multi-video installation *The best animals are the flat animals*, the artist acknowledges Riley's desire to extend flat space optically into the realm of the viewer. As Fereshteh Daftari has observed about Thater's electronic, Riley-influenced environment, 'Those who enter abandon the modernist anxiety about depth,' epitomised by Frank Stella's often quoted dictum, 'what you see is what you see', as a zebra is put through a series of tricks, its stripes seeming to jump off the 'canvas', filling the walls of the gallery with vibrating, disembodied stripes which turn out to be a migrating herd in close-up.[36] Beside this 'living' black and white stripe painting, Riley's name is brightly emblazoned on another monitor.

It is clear that the proscriptive perspective of Greenberg-style Modernism has inhibited the fullest possible consideration of Riley's contribution. The critique of its premises had already begun at the time of her emergence on the scene, paving the way for new questions to frame her work, its reception and its distribution, and to revise her position within the broader context of visual culture of the past three decades. The moment is particularly opportune for this exhibition of paintings for which she is best known, at a time when painting is being reconsidered and reconceived, when 'a new formalism' is being heralded on the covers of *Artforum* and *frieze* magazines. Perhaps the greatest challenge for these new Formalists is how to elide making empty Formalist works that look like a re-run of sixties abstraction, to employ formalism as a tool, without turning it into a stylish look. To assume Formalism as a style is also to bear the burden of its heavy historical baggage and the weight of its ideology. Indeed, there can only be 'knowing' painting after

32. See Lisa Corrin, 'Hanging by a Thread', in *Loose Threads*, exhibition catalogue, London: Serpentine Gallery, 1998, p. 18.

33. For an excellent discussion of Taaffe's use of pattern and decoration, see Francesco Pellizzi, 'Fragment and Ornament', *Parkett*, vol. 26, 1990, pp. 98-111.

34. See James Yood, 'Post-Hypnotic', *Artforum*, April 1999, p. 120.

35. Loc. cit.

36. See Fereshteh Daftari, 'Diana Thater', brochure for *Diana Thater: Projects 64*, New York: Museum of Modern Art, 1998.

Diana Thater
Bridget Riley made a painting, 1998
Installation for LCD video projector, three-lens video projectors, laser disk players, laser disks, window film
Courtesy 1301PE and the MAK Centre for Art and Architecture, Los Angeles

the critique of Modernism that has been the basis of a transforming debate within culture generally over the past thirty years.

It is impossible simply to look with a 'pure' and unmediated eye at Riley's paintings, since their history encompasses their consumption as much as it does their production and their place within the development of Abstract art. Many artists today, in attempting to recapture something of the flavour of the Swinging Sixties often respond to what seems, on the surface, to be their naivety. The misconstruction of Bridget Riley as the icon of that moment, suggests that it was also a time of lost innocence. The gauntlet is thrown down for artists, scholars and theorists to return to Riley's work with the critical tools and sensibility of the late twentieth century, not only in order to examine her paintings, but also the discourses and constructions surrounding them. In true Riley spirit, the results should be precarious, fearless and destabilising.

PLATES

1 **Kiss** 1961

4 Black to White Discs 1962

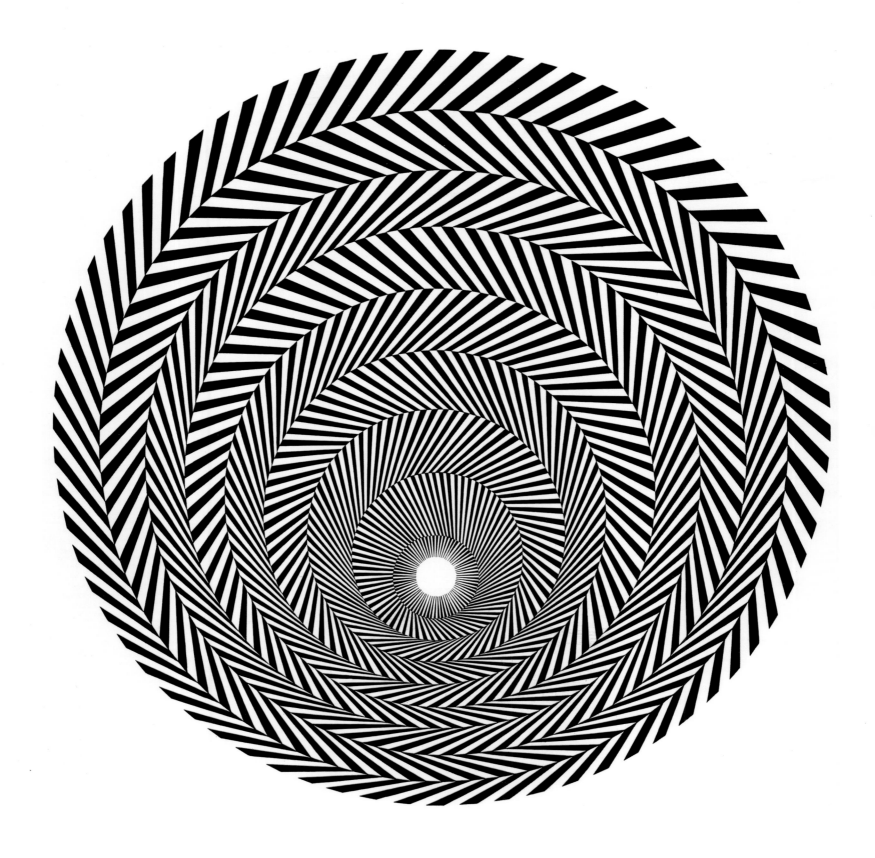

9 White Discs 2 1964

11 **Burn** 1964

12 Turn 1964

13 Pause 1964

14 Serif 1964

16 Current 1964

18 Descending 1965

19 Arrest 2 1965

20 **Static 2** 1966

21 Breathe 1966

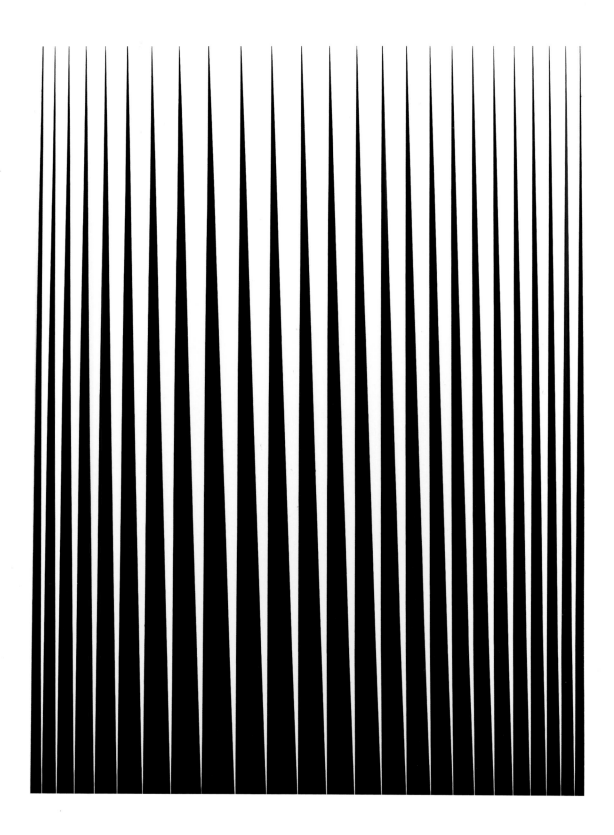

22 Deny 2 1967

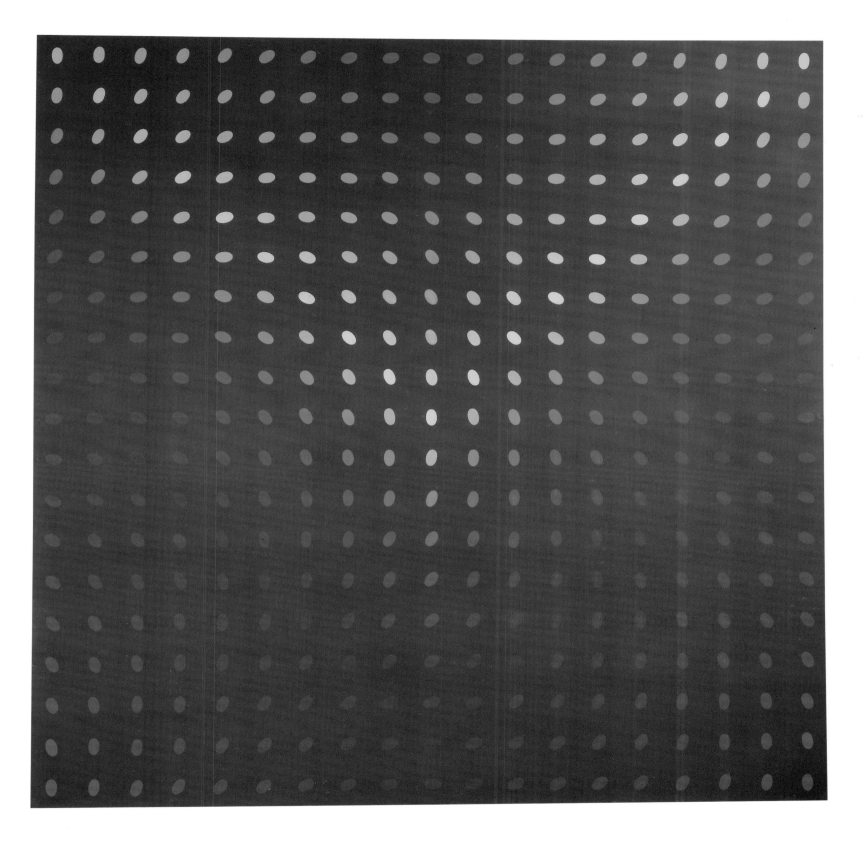

23 Cataract 3 1967

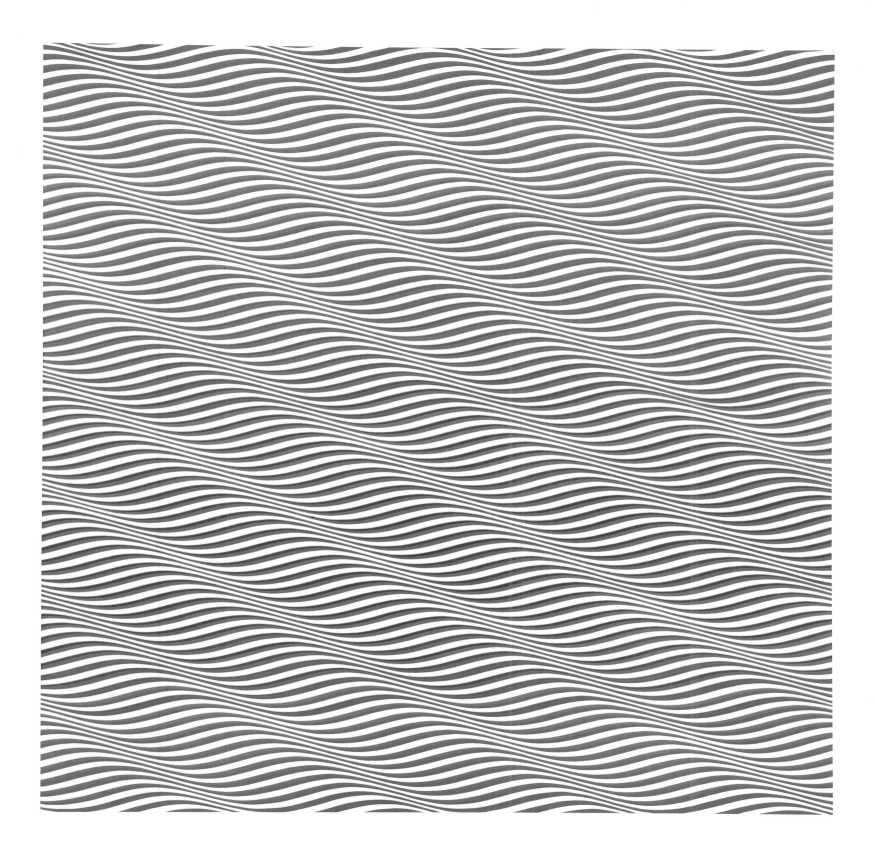

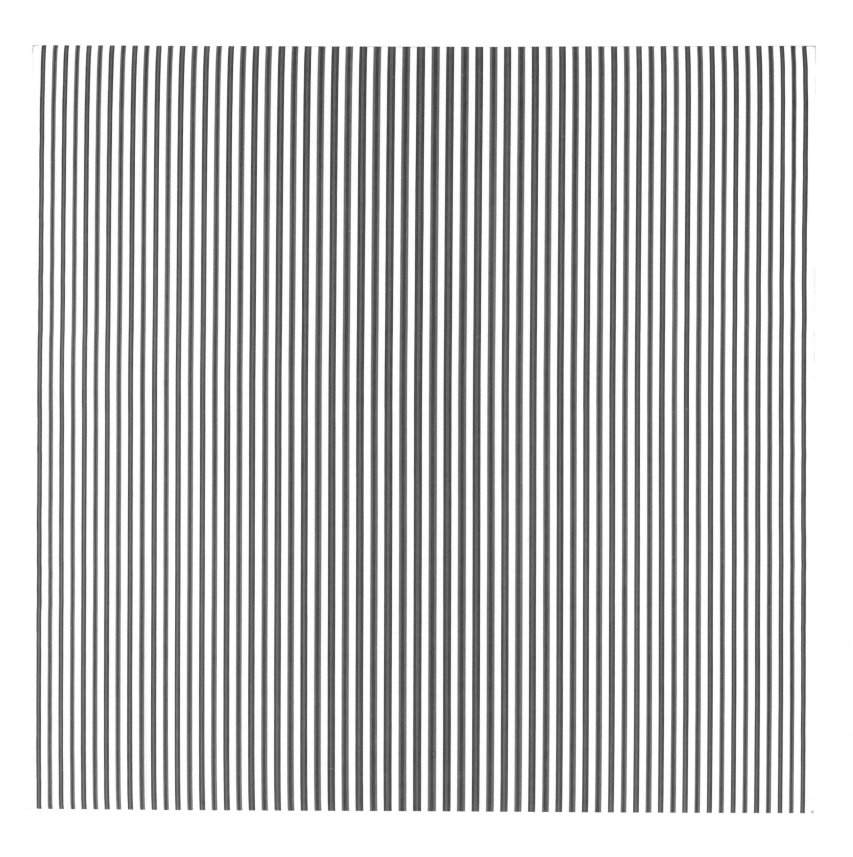

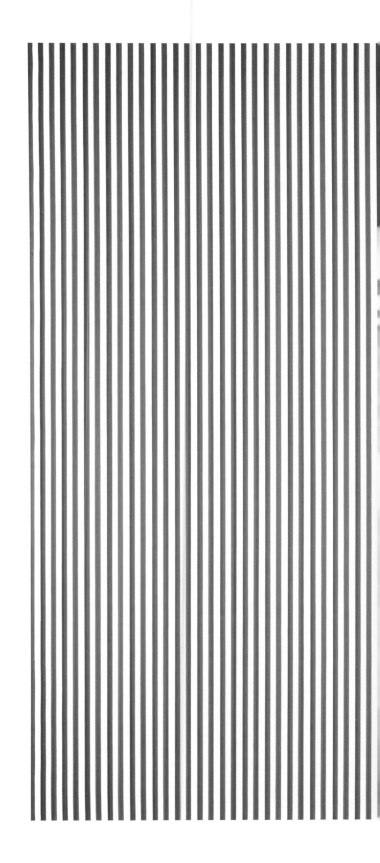

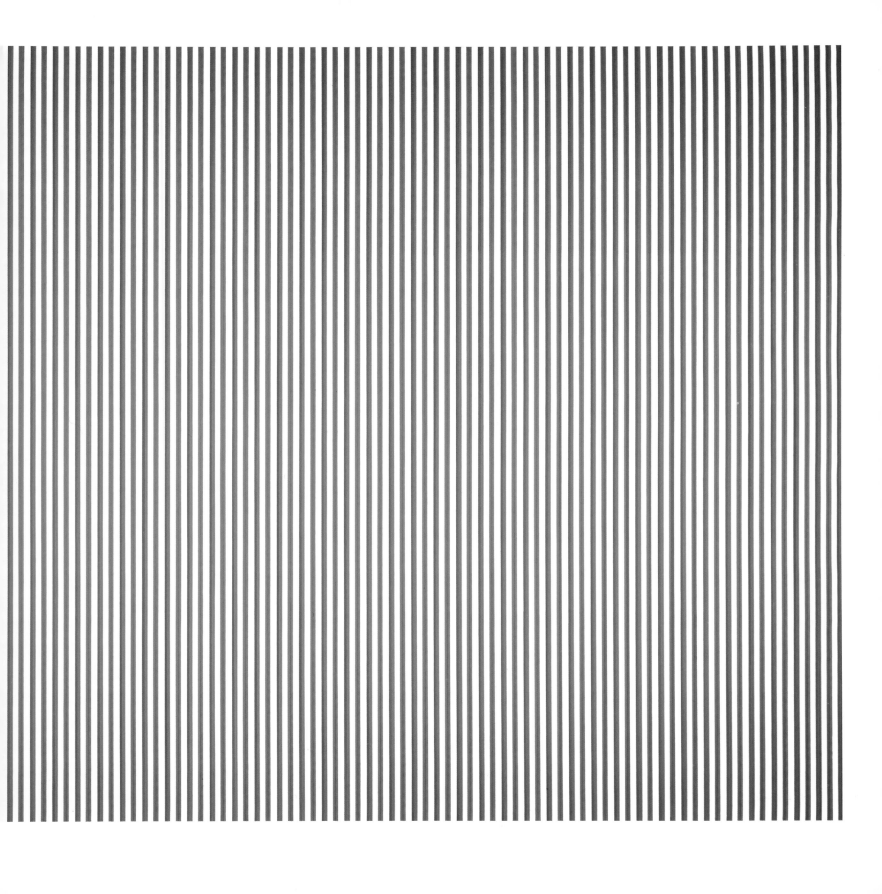

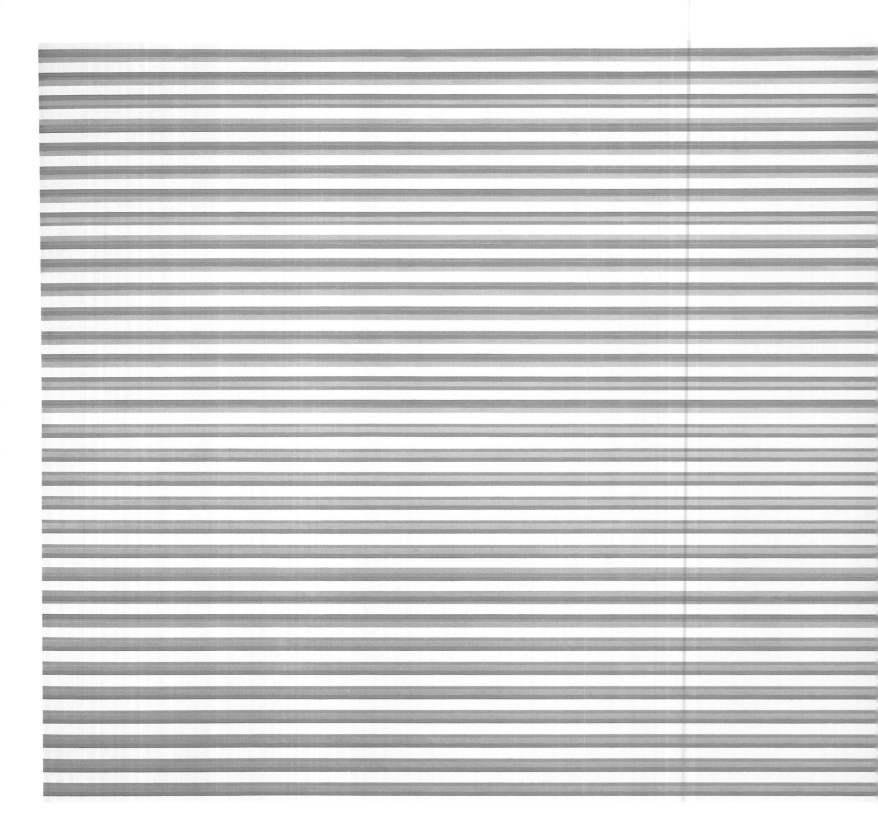

29 Cantus Firmus 1972-73

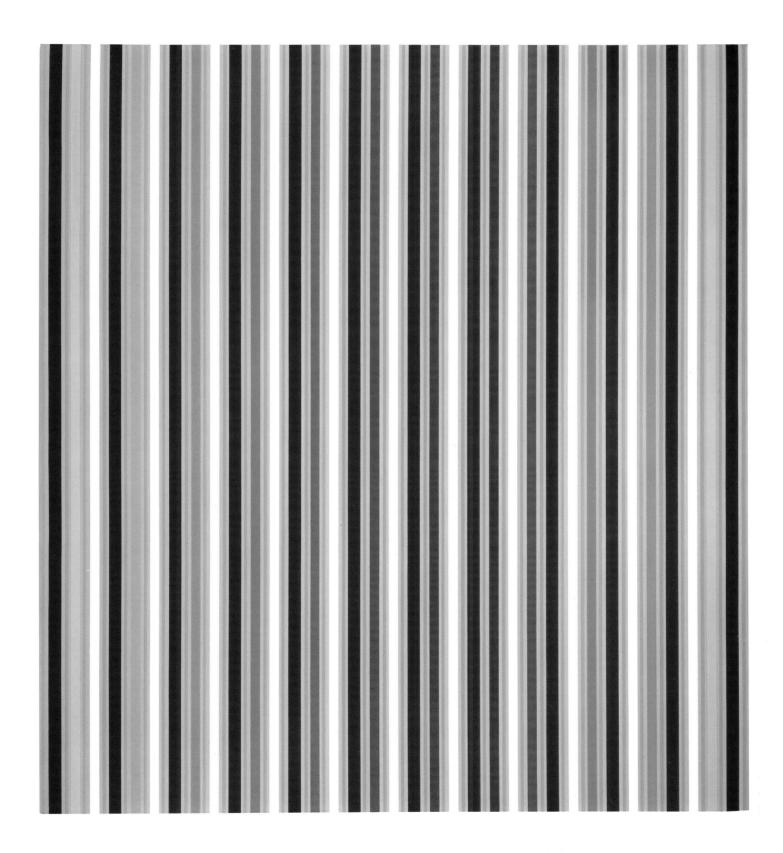

31 Aurulum 1977

33 **Andante** 1980-81

1 **Kiss** 1961
Acrylic on linen
122×122 cm / 48×48 in
Private collection

2 **Movement in Squares** 1961
Tempera on hardboard
123.2×121.3 cm / 48½×47¾ in
Arts Council Collection
Hayward Gallery, London

3 **Horizontal Vibration** 1961
Tempera on hardboard
44.5×141 cm / 17½×55½ in
Collection Manfred Wandel,
Reutlingen

4 **Black to White Discs** 1962
Emulsion on canvas
177.8×177.8 cm / 70×70 in
Private collection

5 **Uneasy Centre** 1963
Emulsion on wood
39 cm diameter / 15⅜ in diameter
Private collection, London
Courtesy Karsten Schubert

6 **Shift** 1963
Emulsion on hardboard
76.2×76.2 cm / 30×30 in
Collection Helga and
Edzard Reuter, Stuttgart

7 **Fission** 1963
Tempera on hardboard
88.8×86.2 cm / 35×34 in
The Museum of Modern Art,
New York, Gift of Philip Johnson,
1969

8 **Blaze 4** 1964
Emulsion on hardboard
94.6×94.6 cm / 37¼×37¼ in
Private collection

9 **White Discs 2** 1964
Emulsion on hardboard
104×99 cm / 41×39 in
Private collection

10 **Shiver** 1964
Emulsion on hardboard
68.5×68.5 cm / 27×27 in
Private collection

11 **Burn** 1964
Emulsion on hardboard
56×56 cm / 22×22 in
Private collection

12 **Turn** 1964
Emulsion on hardboard
49.5×49.7 cm / 19½×19⅝ in
Private collection

13 **Pause** 1964
Emulsion on hardboard
115.6×116.2 cm / 45½×45¾ in
Private collection

14 Serif 1964
Emulsion on hardboard
162×162 cm / 63¾×63¾ in
m Bochum Kunstvermittlung,
Bochum, Germany

15 Crest 1964
Emulsion on hardboard
166×166 cm / 65⅜×65⅜ in
The British Council

16 Current 1964
Emulsion on hardboard
148.5×149.5 cm / 58⅜×58⅞ in
The Museum of Modern Art,
New York, Philip Johnson Fund, 1964

17 Where 1964
Emulsion on hardboard
106.7×113 cm / 42×44½ in
The Family of Paul M. Hirschland

18 Descending 1965
Emulsion on hardboard
91.4×91.4 cm / 36×36 in
Private collection

19 Arrest 2 1965
Acrylic on linen
195×190 cm / 76⅝×75 in
Private collection

20 Static 2 1966
Emulsion on canvas
229.9×229.9 cm / 90½×90½ in
Private collection

21 Breathe 1966
Emulsion on canvas
298×208.5 cm / 117⅜×82⅛ in
Museum Boijmans Van Beuningen,
Rotterdam

22 Deny 2 1967
Emulsion on canvas
217.2×217.2 cm / 85½×85½ in
Tate Gallery, purchased 1976

23 Cataract 3 1967
PVA on canvas
221.9×222.9 cm / 87⅜×87¾ in
The British Council

24 Chant 2 1967
Emulsion on canvas
231.5×231 cm / 91×90 in
Neues Museum. Staatliches Museum
für Kunst und Design in Nürnberg.
On loan from a private collection

25 Late Morning 1967-68
PVA on canvas
226.1×359.4 cm / 88⅞×141⅝ in
Tate Gallery, purchased 1968

26 Rise 1 1968-70
Acrylic on canvas
188×376 cm / 74×148 in
Sheffield Galleries and
Museums Trust

27 Byzantium 1969
Acrylic on canvas
165×370 cm / 65×145½ in
Westfalenbank AG, Bochum

28 Zing 1 1971
Acrylic on canvas
101.5×89 cm / 40×35 in
Private collection

29 Cantus Firmus 1972-73
Acrylic on linen
241.3×215.9 cm / 95×85 in
Tate Gallery, purchased 1974

30 Entice 2 1974
Acrylic on linen
154.3×137.5 cm / 60¾×54⅛ in
Camille Oliver Hoffmann

31 Aurulum 1977
Acrylic on linen
132×122 cm / 52×48 in
Heinz Teufel and
Anette Teufel-Habbel, Berlin

32 Song of Orpheus 5 1978
Acrylic on linen
196×260 cm / 77×102¼ in
Courtesy Karsten Schubert

33 Andante 1980-81
Acrylic on linen
182×169 cm / 71⅝×66 in
Private collection

BIOGRAPHICAL NOTE

EXHIBITION HISTORY

Selected Solo Exhibitions

1931
Born in London

1949-52
Goldsmiths College, London

1952-55
Royal College of Art, London

1968
International Prize for Painting,
XXXIV Venice Biennale

1993
Honorary Doctor of the University of Oxford

1995
Honorary Doctor of the University of Cambridge
Visiting Professor, De Montfort University,
Leicester

Lives and works in London, Cornwall
and France

1962
Gallery One, London

1963
Gallery One, London
University Art Gallery, Nottingham

1965
Richard Feigen Gallery, New York
Feigen-Palmer Gallery, Los Angeles

1966
(Prints) Robert Fraser Gallery, London
(with Harold Cohen)
(Drawings) Richard Feigen Gallery, New York

1966-67
Bridget Riley, Drawings, The Museum of Modern Art,
New York, and touring USA

1967
(Drawings) Robert Fraser Gallery, London
Richard Feigen Gallery, New York

1968
Richard Feigen Gallery, New York
XXXIV Venice Biennale, British Pavilion,
(with Phillip King); touring to Städtische Kunstgalerie,
Bochum; Museum Boijmans Van Beuningen, Rotterdam

1969
Rowan Gallery, London
(Drawings) Bear Lane Gallery, Oxford; Arnolfini Gallery,
Bristol; Midland Group Gallery, Nottingham

1970
(Prints) Kunstudio Bielefeld

1970-71
Paintings and drawings 1951-71, Arts Council of Great
Britain retrospective exhibition; touring to Kunstverein
Hannover; Kunsthalle Berne; Städtische Kunsthalle
Düsseldorf; Museo Civico, Turin; Hayward Gallery, London;
National Gallery Prague

1971
(Drawings) Rowan Gallery, London

1972
(Drawings) Rowan Gallery, London
(Recent paintings, drawings and prints)
Städtisches Museum, Göttingen

1973
Paintings and Drawings 1961-73, Arts Council
of Great Britain exhibition; touring to Whitworth Art
Gallery, Manchester; Mappin Art Gallery, Sheffield;
D.L.I. Museum and Arts Centre, Durham; Scottish National
Gallery of Modern Art, Edinburgh; City Museum and Art
Gallery, Birmingham; Museum and Art Gallery, Letchworth;
City Art Gallery and Arnolfini Gallery, Bristol

1974
Bridget Riley : Graphics '62-'74, MacRobert Centre,
University of Stirling; Collins Exhibition Hall, Stirling;
Aberdeen Art Gallery, Schoolhill

1975
(Paintings and gouaches) Galerie Beyeler, Basel
Sidney Janis Gallery, New York

1976
(Paintings and gouaches) Rowan Gallery, London
(Paintings and gouaches) Coventry Gallery, Sydney

1977
(Paintings and gouaches) Minami Gallery, Tokyo

1978
Sidney Janis Gallery, New York

1978-80
Bridget Riley : Works 1959-78, British Council retrospective
exhibition; touring to Albright-Knox Art Gallery, Buffalo,
NY; Dallas Museum of Fine Art; Neuberger Museum,
Purchase, NY; Art Gallery of New South Wales, Sydney;
Art Gallery of Western Australia, Perth; National Museum
of Modern Art, Tokyo

1979
(Drawings) Australian Galleries, Melbourne;
Bonython Gallery, Adelaide

1980
Fruit Market Gallery, Edinburgh
(Paintings and studies) Art Line, The Hague

1980-82
Bridget Riley Silkscreen Prints 1965-78, Arts Council of Great Britain exhibition; touring UK

1981
Recent Paintings and Gouaches, Rowan Gallery and Warwick Arts Trust, London
(Gouaches) Juda Rowan Gallery, London

1984
Bridget Riley, Project for the Royal Liverpool Hospital, Royal Institute of British Architects, London

1984-85
Working with Colour, Arts Council of Great Britain exhibition; D.L.I. Museum and Arts Centre, Durham, and touring UK
(Paintings and gouaches) Galerie Reckermann, Cologne

1985
Bridget Riley, Selected Works 1963-1984, Goldsmiths' College Gallery, London
(Paintings and gouaches) Nina Freudenheim Gallery, Buffalo, NY

1986-87
South Western Art Galleries Association exhibition, touring Scotland

1987
(Paintings and gouaches) Galerie Konstructiv Tendens, Stockholm
(Paintings and gouaches) Galerie und Edition Schlégl, Zurich
Bridget Riley, New Work, Mayor Rowan Gallery, London

1988
(Paintings and gouaches) Galerie Teufel, Cologne

1989
(Paintings and gouaches) Galerie und Edition Schlégl, Zurich
Bridget Riley, Works on Paper, Mayor Rowan Gallery, London

1990
Sidney Janis Gallery, New York
Nishimura Gallery, Tokyo

1992-93
Bridget Riley, Paintings 1982-1992, Kunsthalle Nürnberg; Josef Albers Museum, Quadrat Bottrop; Hayward Gallery, London; Ikon Gallery, Birmingham
Bridget Riley, Works on Paper, 1982-1992, Karsten Schubert, London

1993
Bridget Riley : Colour Studies, Karsten Schubert, London

1994
Bridget Riley : Six Paintings 1963-1993 from the Collection, Tate Gallery, London

1995
Bridget Riley : Recent Paintings and Gouaches, Kettle's Yard, Cambridge
Bridget Riley : Recent Works : Paintings and Gouaches 1980-1995, Spacex Gallery, Exeter

1996
Bridget Riley : Recent Paintings and Gouaches, Waddington Galleries and Karsten Schubert, London
Bridget Riley : Paintings and Gouaches 1980-1995, Leeds City Art Gallery

1997
Bridget Riley : Selected Works from 1980 onwards, Green on Red Gallery, Dublin

1998
Bridget Riley, Galerie Michael Sturm, Stuttgart

1998-99
Bridget Riley : Works 1961-1998, Abbot Hall Art Gallery, Kendal

1999
Bridget Riley : Paintings from the 1960s and 70s, Serpentine Gallery, London

Selected Group Exhibitions

1955
Young Contemporaries, RBA Galleries, London

1958
Diversion, South London Art Gallery

1959
Some Contemporary British Painters, Wildenstein Galleries, London

1963
1962 One Year of British Art, Tooths Gallery, London
John Moores Exhibition, Walker Art Gallery, Liverpool

1964
The New Generation, Whitechapel Art Gallery, London
Nouvelle Tendance, Musée des Arts Décoratifs, Paris
Ten Years, Gallery One, London
Profile III, Englische Kunst der Gegenwart, Städtisches Kunstmuseum, Bochum
Marzotto Prize Exhibition, Italy and touring Europe
Six Young Artists, Arts Council of Great Britain exhibition; touring the UK
Pittsburgh International, Carnegie Institute, Pittsburgh, Pennsylvania
Young Artists Biennale, Tokyo

1964-65
Contemporary British Painting and Sculpture, Albright-Knox Art Gallery, Buffalo, NY

1965
The Responsive Eye, The Museum of Modern Art, New York, and touring USA
The Great Society : a Sampling of its Imagery, Art Forum Inc., Haverford, Pennsylvania
A New York Collector Selects, (Mrs Burton Tremaine), San Francisco Museum of Modern Art
1+1=3, Retinal Art, University of Texas, Austin; Tel Aviv Museum, Israel
4e Biennale des Jeunes Artistes, Paris
The English Eye, Marlborough-Gerson Gallery, New York
John Moores Exhibition, Walker Art Gallery, Liverpool

1965-66

London, The New Scene, Walker Art Centre, Minneapolis, and touring USA

Motion and Movement, Contemporary Arts Centre, Cincinatti

1966

Group Exhibition, Galerie Aujourd'hui, Brussels

Aspects of New British Art, Auckland, and touring New Zealand and Australia

London Under Forty, Galleria Milano, Milan

English Graphic Art, Galerie der Spiegel, Cologne

Multiplicity, Institute of Contemporary Art, Boston

1967

Drawing Towards Painting 2, Arts Council of Great Britain exhibition; touring UK

Op Art, Londonderry, Dublin and Belfast

British Drawings, The Museum of Modern Art, New York, and touring USA

Pittsburgh International, Carnegie Institute, Pittsburgh, Pennsylvania

Premio International de Escultura, Instituto di Tella, Buenos Aires

Acquisitions of the Sixties, The Museum of Modern Art, New York

Recent British Painting from the collection of the Peter Stuyvesant Foundation, New York ; Tate Gallery, London

English and American Graphics '67, from The Museum of Modern Art, New York, Belgrade and touring Yugoslavia, organised by Gene Baro

Jeunes Peintres Anglais, Palais des Beaux Arts, Brussels

1968

The New Generation : 1968 Interim, Whitechapel Art Gallery, London

Britische Kunst Heute, Kunstverein Hamburg

Graphics Exhibition, Museum of Modern Art, Oxford

European Painters of Today, Musée des Arts Décoratifs, Paris, and touring USA

20th Century Art, Fondation Maeght, Saint Paul de Vence

British Artists : 6 Painters, 6 Sculptors, The Museum of Modern Art, New York, and touring USA

New British Painting and Sculpture, organised by the

Whitechapel Art Gallery, touring USA and Canada

Plus by Minus : Today's Half Century, Albright-Knox Art Gallery, Buffalo, NY

Junge Generation Großbritannien, Akademie der Künste, Berlin

Documenta IV, Kassel

1969

Contemporary Art : Dialogue between East and West, National Museum of Modern Art, Tokyo

Marks on Canvas, Museum am Ostwall, Dortmund; Kunstverein Hannover; Museum des 20. Jahrhunderts, Vienna

Black White, Smithsonian Institution, Washington; touring USA

1970

Contemporary Paintings from the Sebastian de Ferranti Collection, Whitworth Art Gallery, Manchester

1971

ROSC '71, Royal Dublin Society

1972

Contemporary Prints, Ulster Museum, Belfast

Colour, D.L.I. Museum and Arts Centre, Durham (curated by Nerys Johnson)

8th International Print Biennale, National Museums of Modern Art, Tokyo and Kyoto

1973

La peinture anglaise aujourd'hui, Musée d'Art Moderne de la Ville de Paris

Henry Moore to Gilbert and George : Modern British Art from the Tate Gallery, Palais des Beaux-Arts, Brussels

1974

Graveurs Anglais Contemporains, Musée d'Art et d'Histoire, Cabinet des Estampes, Geneva

Grandes Dames : Petit Formats (Micro-salon 1974), Galerie Iris Clert-Christophle, Paris

British Painting, Hayward Gallery, London

1975

British Exhibition, Art 6 '75, Schweizer Mustermesse, Basel

From Britain '75, Taidelhalli, Helsinki

Contemporary British Drawings, XII Sao Paolo Biennale

1976

Contemporary British Art, Galleries of the Cleveland Institute of Art

Arte Inglese Oggi, Palazzo Reale, Milan

International Drawings selected by the Kunstmuseum Düsseldorf, Düsseldorf Art Fair

Art as Thought Process, XIe Biennale Internationale d'Art, Palais de l'Europe, Menton

1977

Less is More, Sidney Janis Gallery, New York

12th International Exhibition of Graphic Art, Llubliana

British Genius, John Player Foundation, Battersea Park, London

Biennale de Paris, une anthologie : 1959-1967, Paris

Contemporary Drawing, Western Australian Art Gallery, Perth

British Artists of the 60's, Tate Gallery, London

1978

The Mechanised Image, Arts Council of Great Britain exhibition, City Museum and Art Gallery, Portsmouth, and touring UK

1979

Colour 1950-78, D.L.I. Museum and Arts Centre, Durham (curated by Nerys Johnson)

Sonia Delaunay, Vieira da Silva, Bridget Riley, Galerie Beyeler, Basel Art Fair

1982

Aspects of British Art Today, British Council exhibition touring Japan : Tokyo Metropolitan Museum; Tochigi Prefectural Museum; National Museum of Modern Art, Osaka; Fukuoka Art Museum; Hokkaido Museum of Modern Art, Sapporo

1983

Britain Salutes New York, Marlborough Gallery, New York

1984

A Different Climate, Städtische Kunsthalle, Düsseldorf

Artists Design for Dance 1909-84, Arnolfini Gallery, Bristol

1985

Hayward Annual : 25 Years : Three Decades of Contemporary Art : The Sixties, The Seventies and The Eighties, Hayward Gallery, London

1986

Arte e Scienza, British Pavilion, XLII Venice Biennale

1987

British Art in the 20th Century, Royal Academy of Arts, London; Staatsgalerie, Stuttgart

1988-89

Viewpoints : Postwar Painting and Sculpture from the Guggenheim Museum Collection and major loans, USA tour
The Presence of Painting : Aspects of British Abstraction 1957-88, South Bank Centre, London; touring to Mappin Art Gallery, Sheffield and other UK venues

1989

The Experience of Painting : Eight Modern Artists, South Bank Centre, London; touring to Laing Art Gallery, Newcastle upon Tyne, and other UK venues

1991

Konkret Heute in Europa, Galerie Fischer, Lucerne
Künstlerinnen des 20. Jahrhunderts, Museum Wiesbaden
Glasgow's Great British Art Exhibition, McLellan Galleries, Glasgow

1992

Ready Steady Go. Paintings of the Sixties from the Arts Council Collection, South Bank Centre, Royal Festival Hall, London, and touring UK
Summer Group Show : Keith Coventry, Angus Fairhurst, Michael Landy, Bridget Riley, Rachel Whiteread and Alison Wilding, Karsten Schubert, London

1993

The Sixties Art Scene in London, Barbican Art Gallery, London
Karsten Schubert at Aurel Scheibler : Keith Coventry, Michael Landy, Bridget Riley, Rachel Whiteread and Alison Wilding, Aurel Scheibler, Cologne

1993-94

New Realities 1945-1968, Tate Gallery Liverpool

1994

British Abstract Art Part I : Painting, Flowers East Gallery, London
Summer Group Show : Gallery Artists, Karsten Schubert, London

1995

Drawing the Line, South Bank Centre, London; touring to Southampton City Art Gallery; Manchester City Art Gallery; Ferens Art Gallery, Hull; Whitechapel Art Gallery, London
From Here, Waddington Galleries and Karsten Schubert, London

1996

British Abstract Art III : Works on Paper, Flowers East, London
Artists in Print, Green on Red Gallery, Dublin

1997

Treasure Island, Calouste Gulbenkian Foundation, Lisbon
A Quality of Light, Tate Gallery St. Ives

Barrett, Cyril: *Op Art*, Studio Vista, London 1970.

Bowness, Alan: *Recent British Painting* (catalogue), Peter Stuyvesant Foundation Collection, Tate Gallery, London 1967.

Bridget Riley : Dialogues on Art, ed. Robert Kudielka (the artist interviewed by Neil MacGregor, E.H. Gombrich, Michael Craig-Martin, Andrew Graham-Dixon and Bryan Robertson; introduction by Richard Shone), Zwemmer, London 1995.

Bridget Riley : Recent Works : Paintings and Gouaches 1981-1995 (catalogue), Spacex Gallery, Exeter and Karsten Schubert, London 1995.

Bridget Riley : Paintings and Gouaches 1980-1995 (catalogue), Leeds City Art Gallery, Leeds 1996.

Bridget Riley : Works 1961-1998 (catalogue), Abbot Hall Art Gallery, Kendal 1998.

Ehrenzweig, Anton: *Bridget Riley* (catalogue), Gallery One, London 1963.
— 'The Pictorial Space of Bridget Riley', in *Art International*, vol. IX/1, pp. 20-24, February 1965.
— *The Hidden Order of Art*, Weidenfeld & Nicolson, London 1967.

Ehrenzweig, Anton, and David Sylvester (intro.): *Bridget Riley* (catalogue), Gallery One, London 1963.

Friedman, Martin: *London : The New Scene* (catalogue), Walker Art Center, Minneapolis 1965.

Harper, Jenny: *Bridget Riley : An Australian Context* (catalogue), Queensland Art Gallery, Brisbane 1985.

Kudielka, Robert: *Bridget Riley : Works 1959-78* (catalogue), The British Council, London 1978.
— *Bridget Riley : Silkscreen Prints 1965-78* (catalogue), Arts Council of Great Britain, London 1980.
— 'Bridget Riley's Bildnerisches Denken', in *Bridget Riley : Ölbilder und Gouachen* (catalogue), Galerie Reckermann, Cologne 1984.
— *Bridget Riley : Paintings 1982-1992* (catalogue), Kunsthalle Nürnberg and South Bank Centre, London 1992.

— ed., *The Eye's Mind : Bridget Riley : Collected Writings 1965-1999*, Thames & Hudson in association with the Serpentine Gallery and De Montfort University, London 1999.

Licht, Jennifer: *Bridget Riley : Drawings* (catalogue), The Museum of Modern Art, New York 1966.

Mellor, David: *The Sixties Art Scene in London* (catalogue), Barbican Art Gallery, London 1993.

Roberts, James: 'Visual Fabric', interview with Bridget Riley, in *frieze*, no. 6, pp. 20-23, London, September 1992.

Robertson, Russell & Snowdon: *Private View*, Thomas Nelson & Sons, London 1965.

Robertson, Bryan (intro.): *Bridget Riley : Paintings and Drawings 1951-71* (catalogue), Hayward Gallery, Arts Council of Great Britain, London 1971.
— *Bridget Riley* (catalogue), Galerie Beyeler, Basel 1975.

Sausmarez, Maurice de (intro.): *Bridget Riley* (catalogue), Gallery One, London 1962.
— *Bridget Riley : Working Drawings* (catalogue), Bear Lane Gallery, Oxford 1969.
— *Bridget Riley*, Studio Vista, London 1970.

Seitz, William C.: *The Responsive Eye* (catalogue), The Museum of Modern Art, New York 1965.

Thompson, David: 'Bridget Riley', in *The New Generation* (catalogue), Whitechapel Gallery, London 1964.
— *Bridget Riley* (catalogue), XXXIV Venice Biennale, The British Council, London 1968.
— (intro.): *Bridget Riley* (catalogue), Sidney Janis Gallery, New York 1975.
— *Recent British Art* (catalogue), The British Council, London 1977.

Serpentine Gallery
Benefactors

Gallery Renovation
(1996-1997)